Nigel Hall

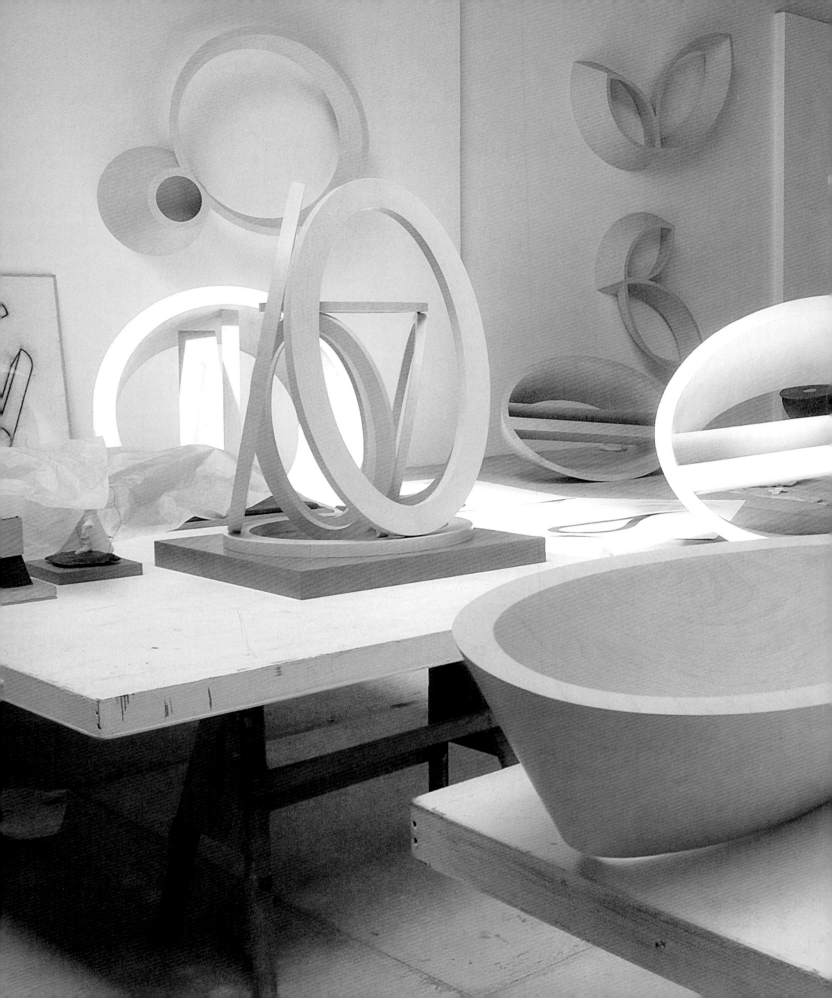

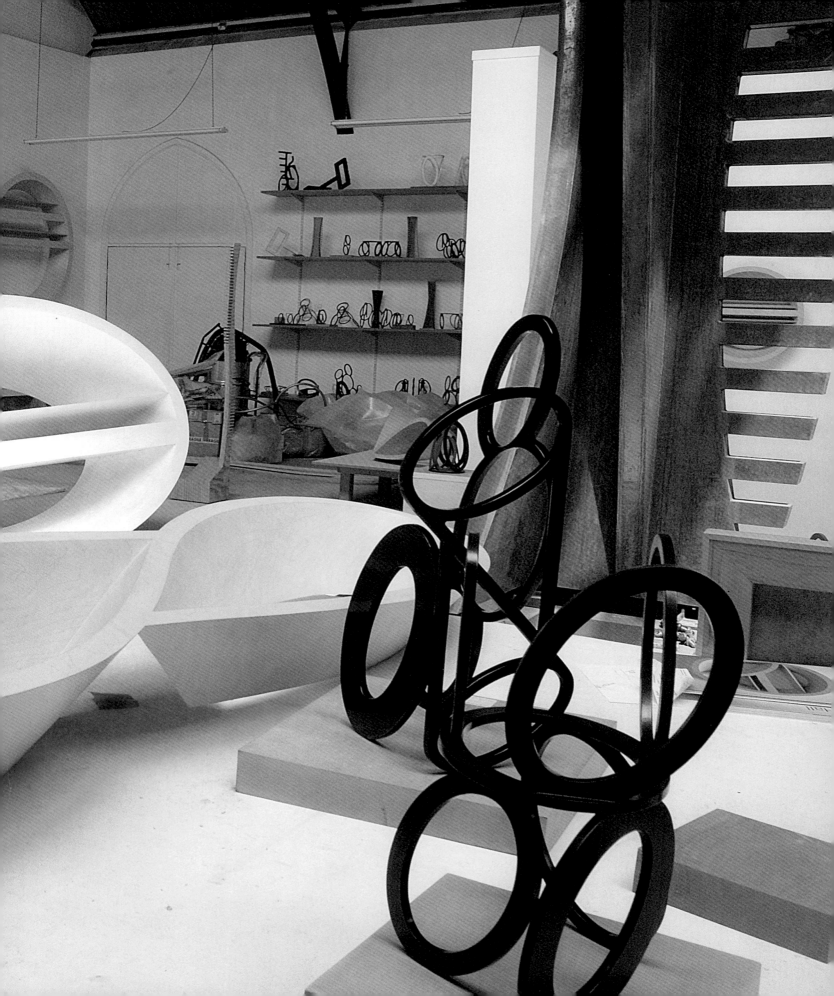

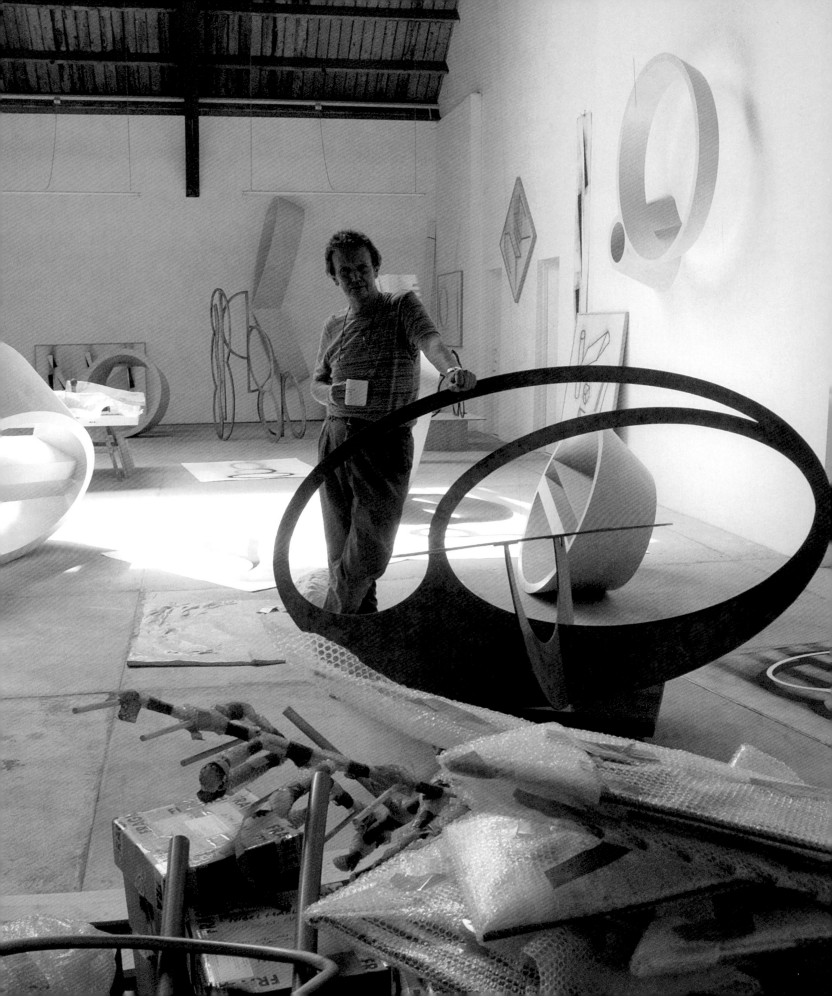

Nigel Hall

Sculpture and Works on Paper

ROYAL ACADEMY OF ARTS

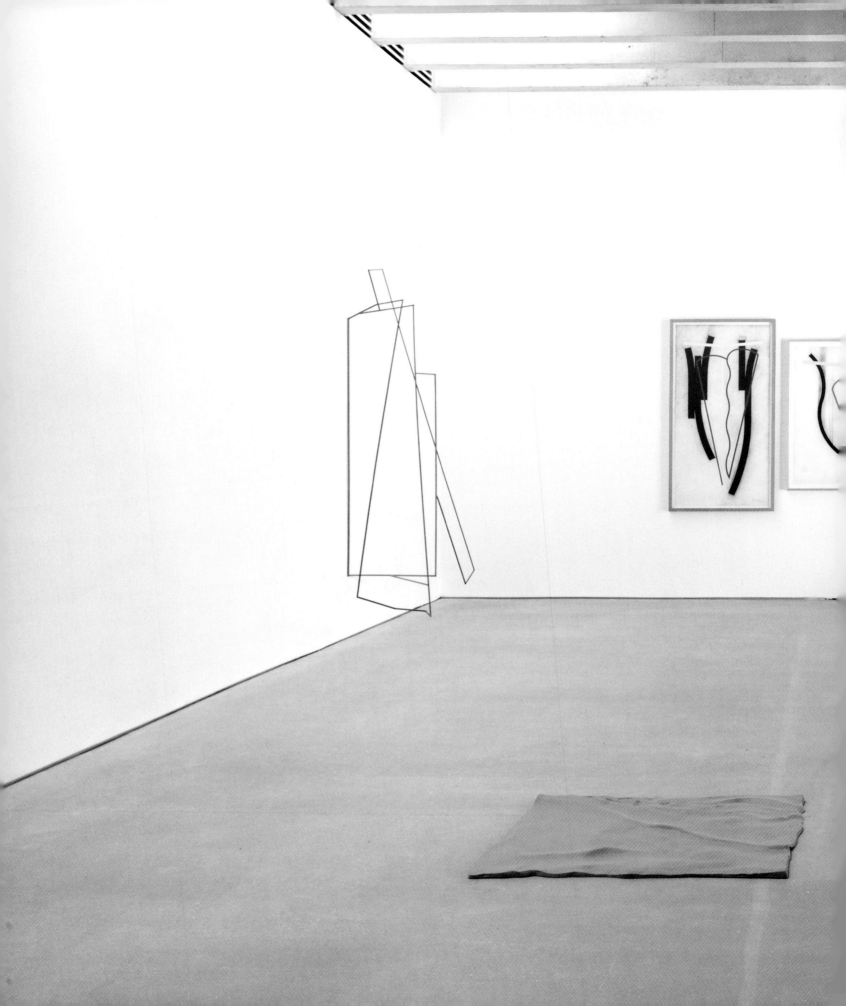

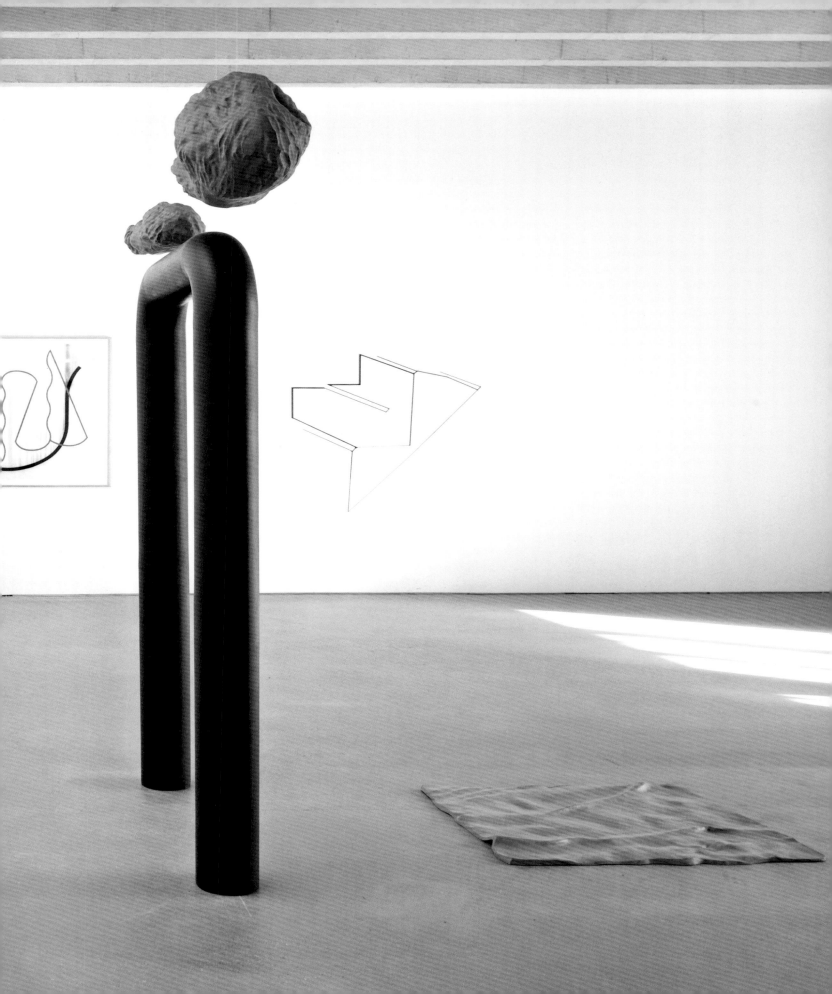

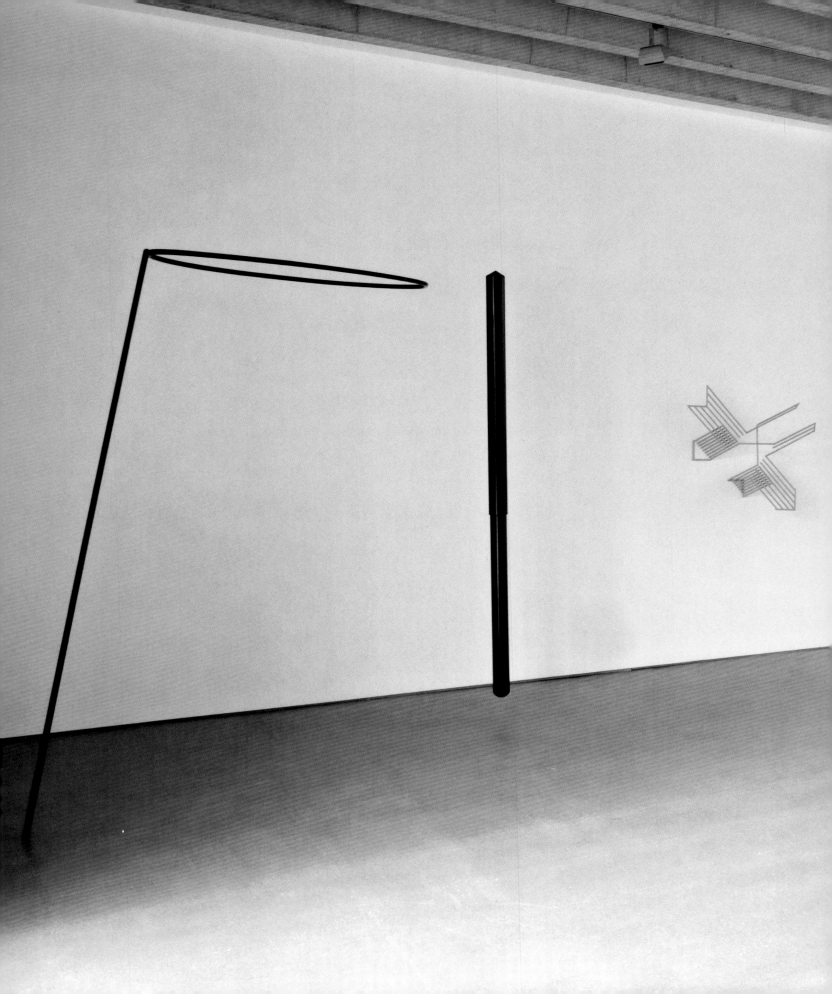

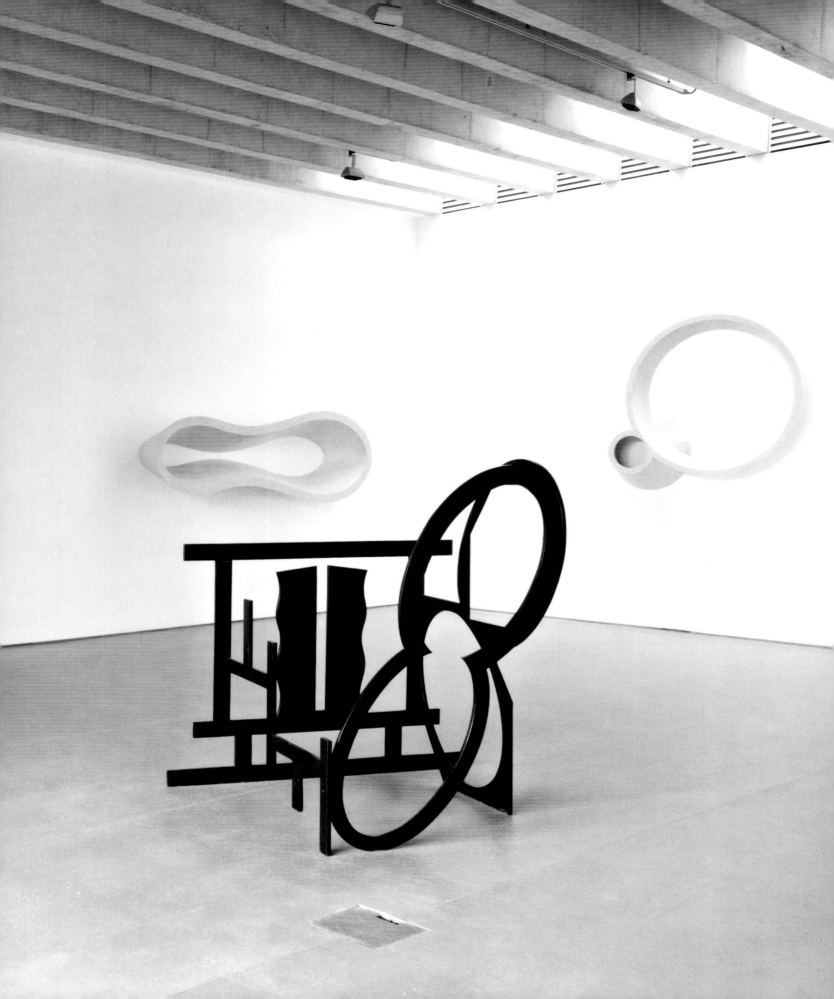

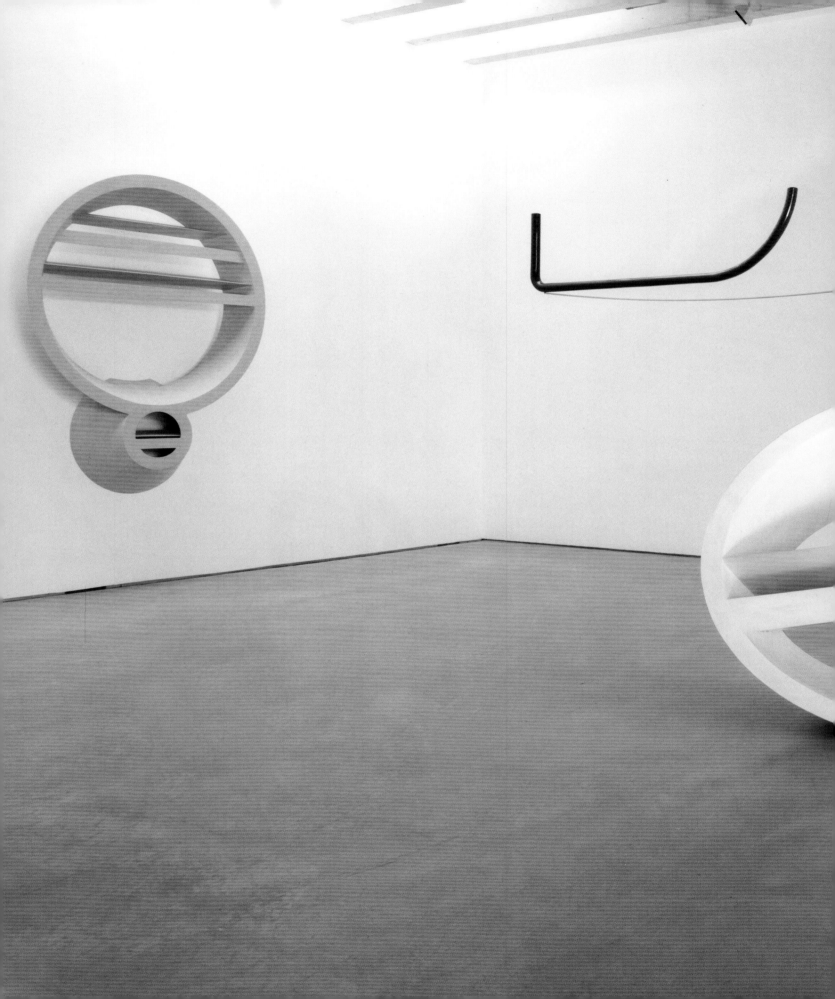

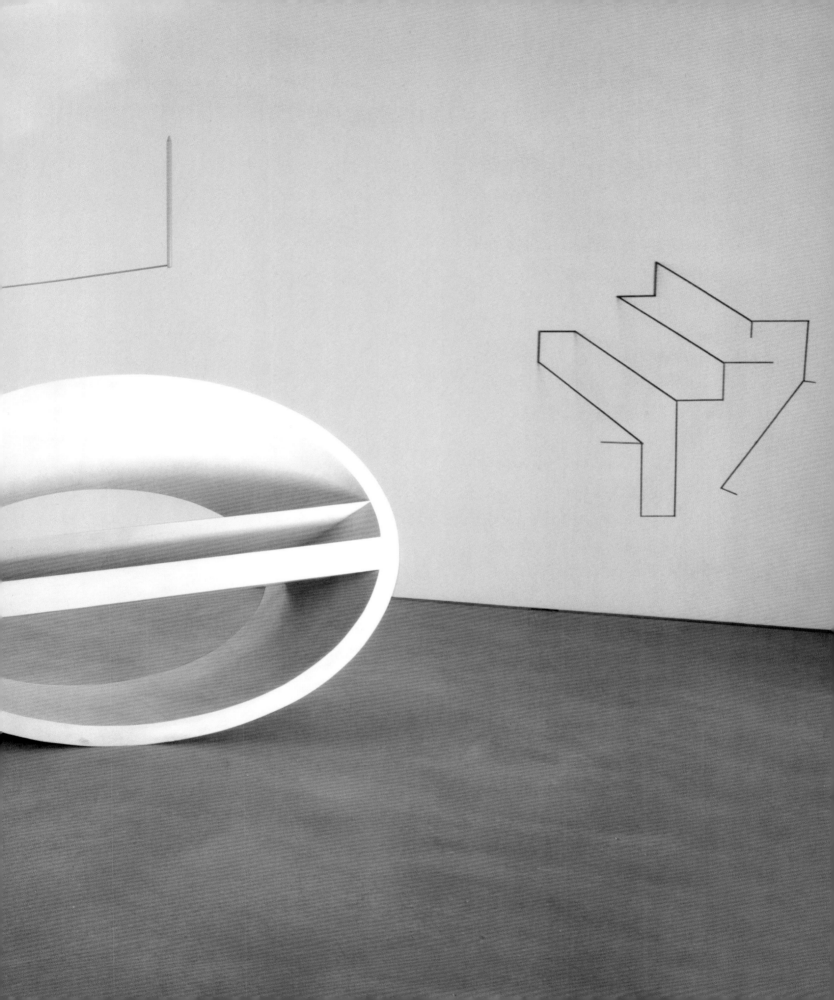

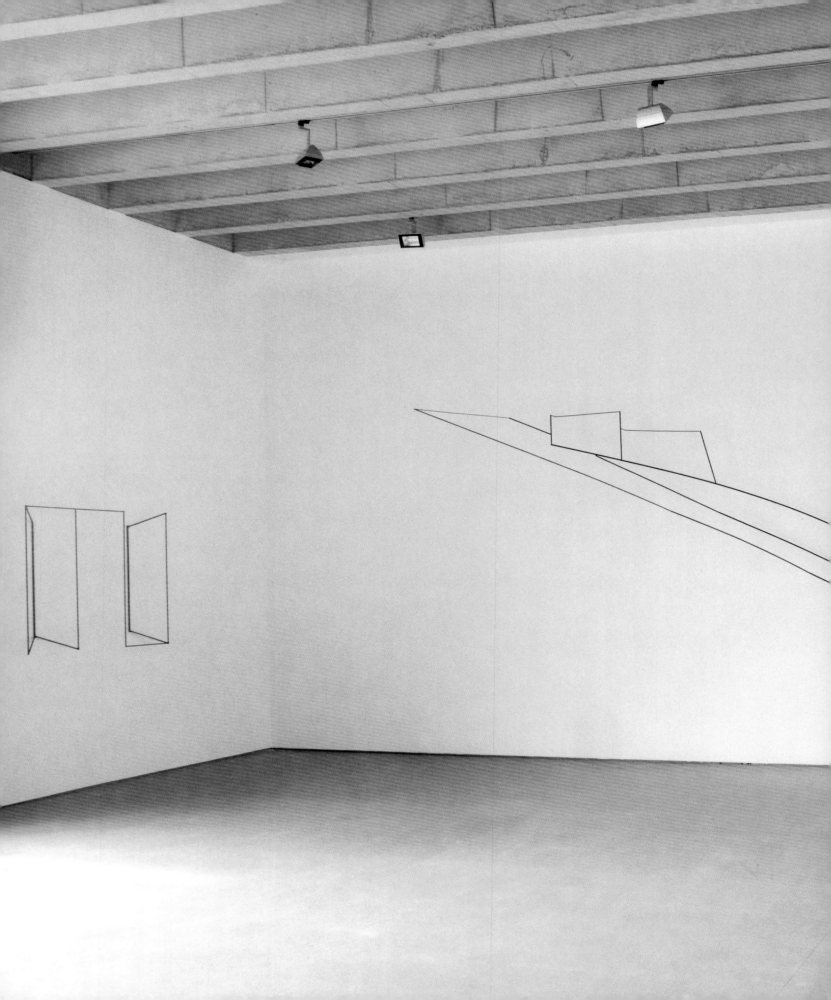

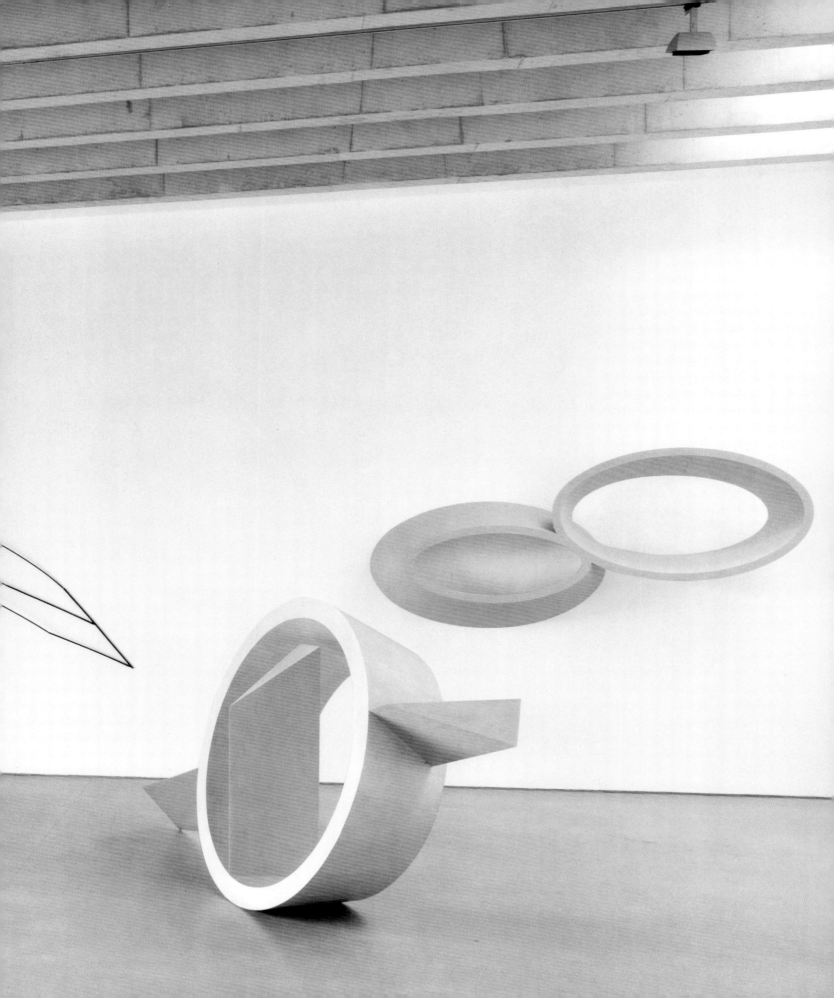

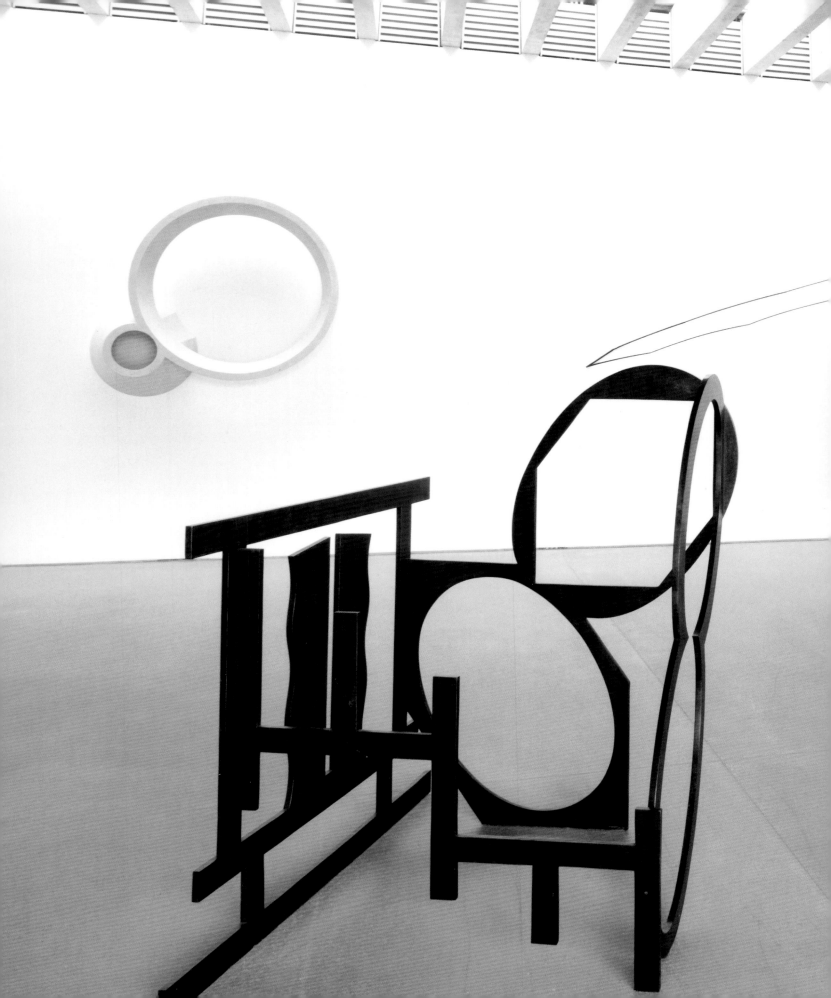

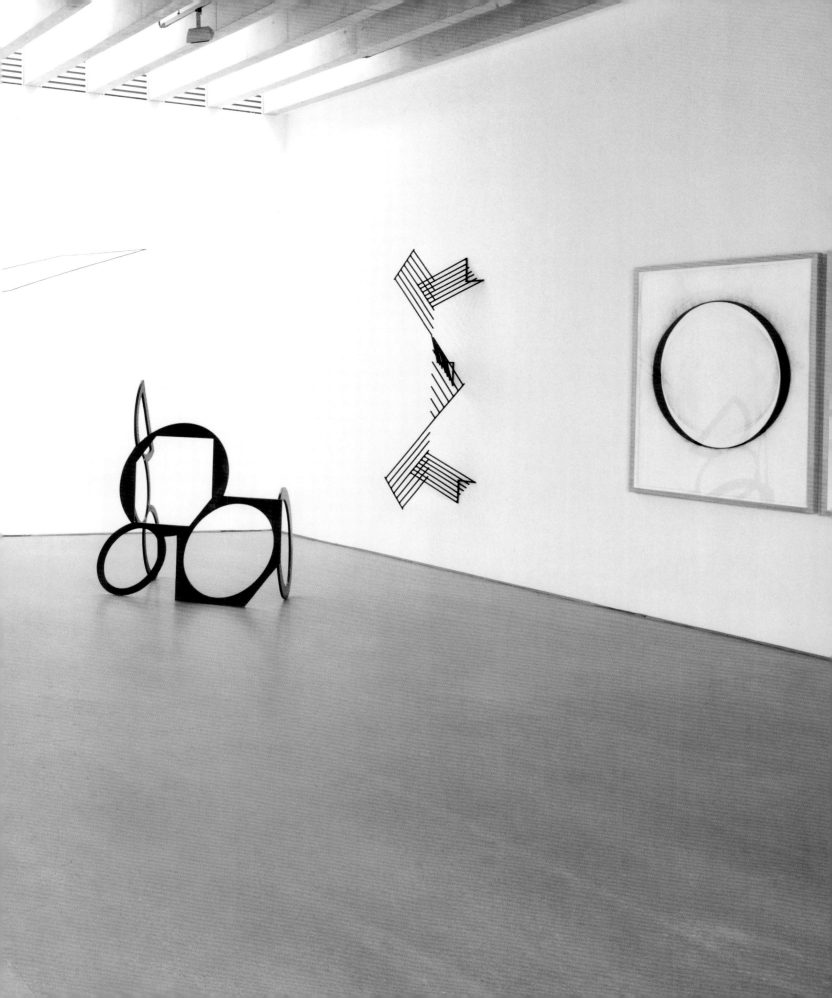

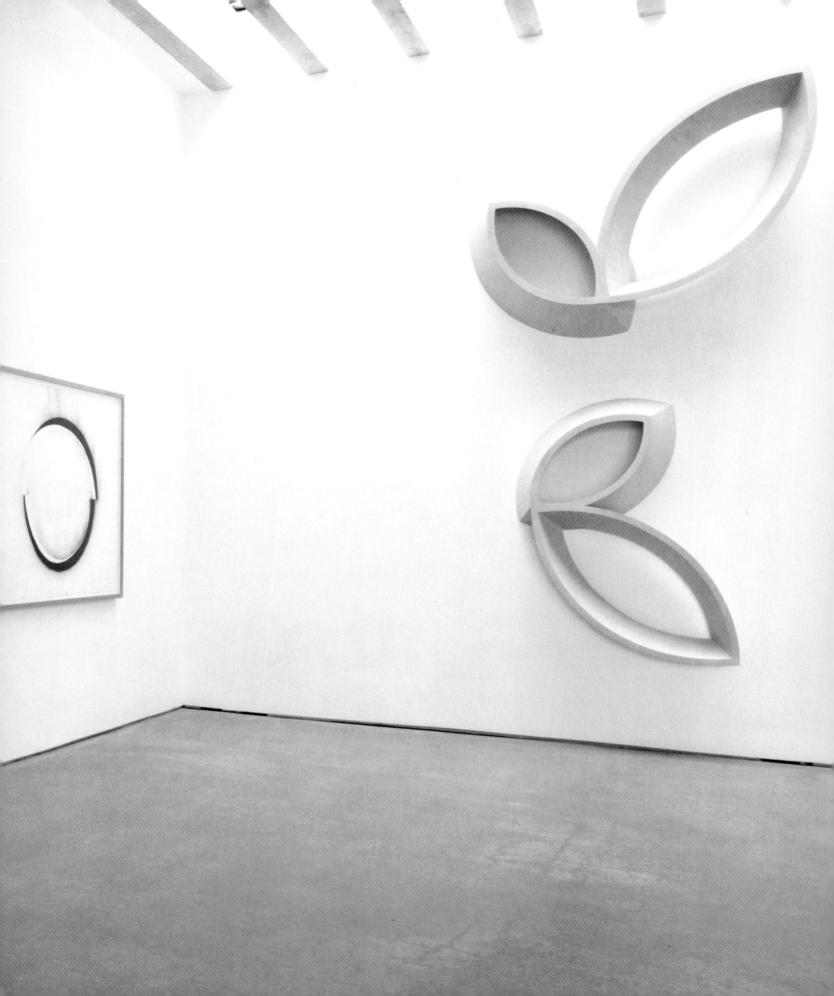

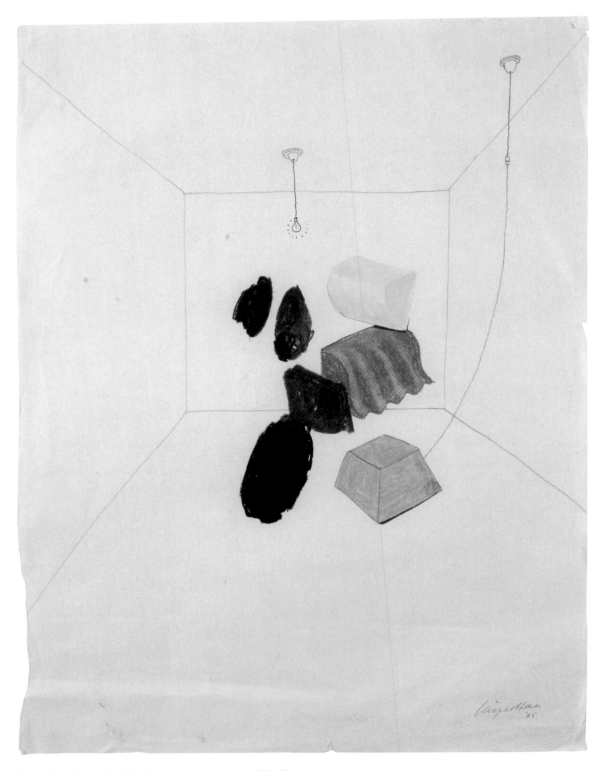

Three Silent Shapes II, 1965 Pencil and pastel on paper 50.8 x 38 cm

Nigel Hall: In His Own Words, Mostly

Nigel Hall lives and works in London. His studio in Balham was originally built as a church hall and consists of one big space (with offices adjoining), measuring 60' x 60' and very high, with a good top light which he put in while closing some of the windows in the walls to increase hanging space. It is an excellent setting in which to show sculpture. Here, since 1991, he has made his work, usually without assistants. The following texts have been extracted from extensive conversations between the artist and Andrew Lambirth recorded for the British Library Sound Archive and subsequently edited.

Beginnings

Hall was born and schooled in Bristol but grew up in the Gloucestershire countryside, thus fruitfully dividing his time between town and country. As a child he was passionate about the sea, and nearly committed himself to a career in the Navy. Some of his first sculptures were little carvings in balsa wood of vessels and ships. His love of the sea has stayed with him.

My grandfather was a stonemason. He used to do a lot of work on renovating churches, cathedrals, and other public buildings mainly in Bristol and the West Country. What I particularly enjoyed was that he was a maker. Although he didn't carry on his trade, due to the economic decline I suppose, he used to work at home on his carvings. And I used to work with him, which was wonderful.

I was brought up on a certain type of French Romanesque stone carving, particularly Gislebertus of Autun. Many years elapsed before I actually went to see the buildings at Moissac and Souillac, Autun and Vézelay and Cluny *in situ*, and they are fantastic – so rich in their depth of light and shade and colour. I mean colour in the way stone is cut rather than applied colour of course. But those places were an absolute delight to me. I haven't been to France for many years, other places have taken over. I've spent a lot of time travelling in Japan and Korea, for instance.

How important has carving been to you?

Carving is cutting a line, or cutting a plane, which traps shadow. And I think this experience of carving has affected the way I make sculpture and drawings, which is very much to do with light and shade, and edge. So if you put a chisel into a piece of stone, you are changing spatial direction in the material. And also you are trapping a shadow, and at the same time you're drawing a line where the light meets dark. And that's how I've always drawn, seeking out that junction between light and dark, and edge.

Being born in 1943, you were a war baby. Were you aware of it?

I'm sure I was too young to remember much if anything of the war. It's just that a lot of my early work has motifs which seem to be connected with it. And when I was a student in Bristol I made a lot of

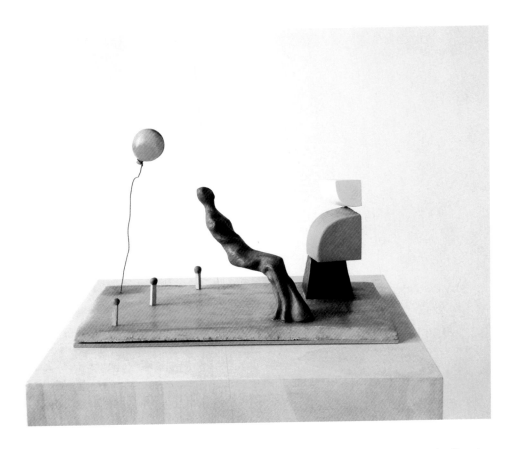

**Figure with Balloon, Matches
and Shapes**, 1965
Painted fibreglass and metal wire
36 x 54 x 29.5 cm

pieces that included elements of explosives or tanks or mines. And I also made pieces at the Royal College which had barrage balloons or searchlights. These things I do remember (see above).

I know that for years after my early childhood, I couldn't be outdoors when a plane flew over, whereas most kids enjoy them. I would rush in. A lot of my early work was aware of spatial areas, such as above head height. It's hard to describe it really, but I had a sense of oppressiveness from above, and made a lot of hanging sculptures that had this spatial awareness.

One's awareness of possible dangers can activate areas of space that can be used. When I was a student, I was terribly keen not to use bases, I wanted to use the real space of the room that we were in to make sculptures. So I made sculptures that were in various elements, separated by space, and they sat directly on the floor. And then I wanted to use the space above the sculptures, so I used a method of suspension, so one could open up the whole space of the room. I also used to make carpets or mats in clay, the counterpart of the suspended forms. So I might make a cloud shape, and then the mat or carpet on the floor was like its shadow, or a way of bracketing the space between the two elements. And I think a lot of that came from childhood memories (see opposite and pp. 23 and 24).

When I arrived at the West of England College of Art in Bristol, I think the first thing we did was to sit down in front of classical plaster casts, and draw those for two or three weeks. And the course really consisted of life drawing, life modelling, life composition, and the subsidiary subjects were anatomy, perspective, letter-cutting, and that was it.

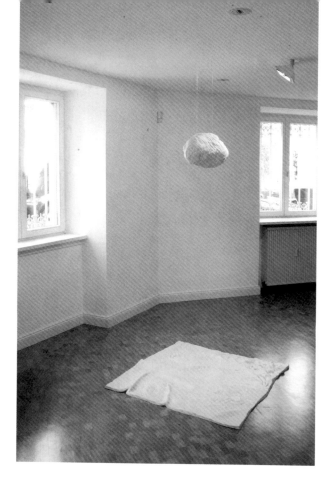

All Space, 1966
Painted fibreglass 183 x 112 x 109 cm

I used to like kite-flying, and when I was living in Gloucestershire I used to go up onto the hills above where we lived which was a perfect place for it. I had big box kites, and I used to let out so much line, the kite was invisible. It was a wonderful sensation linking the fingers with an object that was out of sight. It was an amazing spanning of space connecting the physical world with a sort of mental state, and yet still being in touch with the elements, and feeling the tug of the wind for a long distance and the weight of a line.

Did you ever paint much?

I made oil paintings early on while I was a student at Bristol and did a lot of still-lifes, but I was always very aware of the fact I was moving towards being a sculptor. I even made some paintings as late as the Seventies, quite big canvases. Only about four or five of them, in about 1974. They were really based on the drawings I was making at the time, but transposed into colour. They didn't have a huge significance as far as I could see, so I dropped them.

I make drawings with colour. Having worked through a period of using whites and muted creams, I have over the last couple of years reintroduced quite intense colour, usually in the yellow to orange range. The structure of the recent drawings involves a series of coloured arcs and the central points from which they radiate. Linking these points creates irregular polygons, drawn in charcoal. The relationship between the charcoal and the colour I felt to be analogous to the seed of a flower and its petals. I therefore chose a range of yellows from sharp lemon through chrome to orange as appropriate.

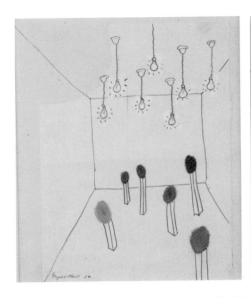 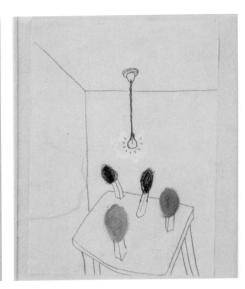

Bomb Factory, 1964 Pencil and pastel on paper 22 x 57 cm

Early Work

*Landscape and the figure have been abiding interests throughout Hall's career as an artist, but never
more in evidence (or actually recognizable) than in his early work. His slightly surreal sculptures of
the 1960s employ a vocabulary of forms which includes rooms with plumb lines or hanging wires,
bare light bulbs, balloons trailing their strings, drapery and especially curtains which conceal, and
matchsticks which have the potential to explode or transform (above). Blossoming into flame like
a crocus bud opens into flower. Expressionistically modelled figures appear in a trance-like state,
leaning back in precarious balance as if tipped up on chairs. The meaning resides as much in the
relationship of elements (contiguity and interval) as it does in any narrative undertones. These are
tableaux charged with tension as well as silence.*

I invented an object that was a four-sided truncated pyramid, on which sat a curved, bread-bin-shaped
object, with a corrugated curved surface, which shifted slightly off the pyramid. Above that again was
the reverse of this curved bread-bin shape, going the other way, and beginning to lift off. And there
was a sense of solidity on the floor, a slipping of the middle unit, and a lifting and levitating third
form. I called this group *Three Silent Shapes* (p. 18), and I used it quite a lot, both in drawings and
sculptures. I was interested in silence, and I was interested in levitation. A lot of this also came at
the time when space exploration was beginning, so there was a lot of awareness of weightlessness,
that 'this way up' wasn't always this way up, if you know what I mean.

 I made tabletop sculptures, some of them quite complex . One of them was about three foot
square, and it had various areas, it was like a landscape with groupings of different elements happen-
ing within it. And then I decided I'd make them on a life-size scale. So I made sculptures that were

Overcast, 1966 Painted fibreglass 350 x 120 x 150 cm

Northwest, 1967 Shown in clay prior to casting in painted fibreglass 245 x 350 x 25 cm

maybe composed of four or five, six elements, but figure size. I placed them straight on the floor, doing away with the base, so that you were able to walk amongst them. These I made when I was in my middle year at the Royal College. And they were quite important for me in that I discovered that you could split an object and pull it apart, and suck in space in between the two elements and there'd be a sort of tension between the two parts of it. And I think you still see it in some of my recent sculptures. There are two pieces, one called *Hidden Valley* (p. 125), the other *Finally Beginning* (p. 108), and both of them are composed of two parts. In the case of *Hidden Valley* there are two ellipses which seem to slide across the joined surfaces. In *Finally Beginning*, there are cones, one inverted, which are either tugging apart or pulling together, could be either. But it's the same sense of space taking an active role or a void taking an active part in the make-up of a sculpture.

How does the sculpture relate to the human figure?

I suppose it relates to certain architectural heights, references to almost doorway height, or window

height, so there's always the sense that the figure completes it somehow. Also I think it's very much about having an encounter with a structure that you live with and see and walk around and spend time with. I think a metaphor for the figure is a hanging vertical, I mean a sense of one's place on the earth and how the vertical is drawn to the earth's core. In nearly all my work, there's either a vertical or a horizontal, or a sense of those orientations. I always feel the figure, or the anticipated presence of the figure, is built into my sculpture.

The Lure of America

Hall was struck by the myth of America from an early age when he began to read the great American writers such as Steinbeck and Hemingway, bought in paperback. He talks lyrically about current favourites such as Hart Crane and Cormac McCarthy. The buildings of Frank Lloyd Wright were another passion, and Hall even toyed with the idea of becoming an architect. America for him was a great and wonderful mystery which has never lost its appeal and refuses to disappoint.

America played quite a large part in my childhood. I liked American literature, I liked American music, and, of course American art, tremendously. I mean, Rothko and Clyfford Still and Rauschenberg, the whole gang really, were the heroes of my generation. Along with Giacometti, who was probably one of the biggest influences at that time. But America certainly was a big draw. And so, when I was approaching the end of my time at the Royal College I thought, what shall I do next? And there was the Harkness Fellowship.

Did you have to apply for it?

You had to apply for it, which I did, and by a miracle I got it. And it was a real cracker of a fellowship, it was two years fully funded anywhere you wanted in America, with no obligations. You had to register, or enrol with a university, and I enrolled with UCLA. I chose to go to California rather than New York. Most artists chose New York, but I chose California because I wanted to be near the desert.

I must have read or heard about the Mojave Desert, and I thought, what a good combination. Los Angeles at that time in the late Sixties was a lively place for film, music and the visual arts. And within a few hours of the city was high desert, wonderful, wonderful landscape, full of magic and mystery. And it really was. I used to take off every so often from my studio, just off Sunset Boulevard in the east part of town, and spend time in the desert. This experience of a seemingly empty landscape taught me a lot in terms of space and economy. It also connected with my delight in the music of Miles Davis and how he used space.

How do you mean, space?

He'd sort of stretch a note till it practically snapped, and he used silence and interval. That you could drop a note here and you'd pick the sound up over there, I thought was a revelation. The ability to bracket space with sound. So it wasn't like filling space with noise, but just indicating here and here

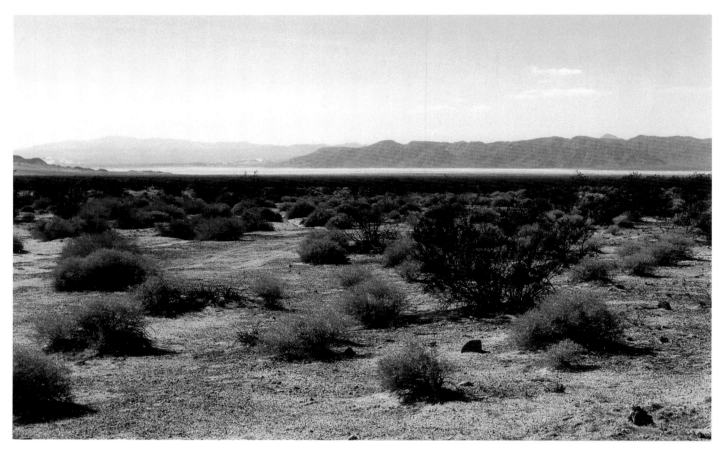

View of Soda Lake, Mojave Desert, California, 1998

and here. Very minimalist and wonderful. And that connects my memory of early Miles Davis with my inexplicable yearning for deserts, which I'd never experienced.

Deserts and the sea.

Deserts and the sea, yes. Very similar.

Well, of course, I suppose deserts are sea beds, aren't they?

Almost the same. Yes, the great expanses of absence of man's mark. And when you do come across man's mark, either in the sea or in the desert, it has a wonderful resonance and great impact.

The Mojave Desert contains a series of dry salt lakes, with wonderful names: Bristol Lake and Turtle Lake and Soda Lake (above). Soda Lake was one of my favourite places. It's very flat, ringed by a few beautiful-coloured oxide red and purple mountains. And I liked just to walk in this landscape. And, one time I was walking there, and there was a rusty pipe of about four-inch diameter sticking

Soda Lake, 1968, with dance choreographed by Richard Alston Dancer: Mark Baldwin

up about three or four feet, in this flat, flat land. And I thought, I wonder what could be the function of this pipe? And I got a little pebble and dropped it down the pipe, and as it went down, it ricocheted off the side, making this extraordinary echoing sound, and hit water after quite a long drop. The echo of the water came back up the pipe, and it was very magical and strange in this silent desert. You could almost gauge the depth below this flat salt lake of the invisible layer of water, the water table. And that moment was the starting point for a series of drawings, and sculptures, one of which is *Soda Lake*, from 1968, which I made in my studio in Los Angeles.

The observer becomes very much a part of these sculptures, they're always very aware of the scale of the human body. And choreographer Richard Alston, who was with the Ballet Rambert in the early 1980s, sensed that and he liked *Soda Lake* as a sculpture, and he also felt it could become part of a dance work with a figure in movement round it. So he made a quite short solo dance piece, also called *Soda Lake*, in 1981, which went into the repertory of the Rambert (below).

Methods and Materials

Nigel Hall is a maker above all else. Not for him the role of impresario of his art, leaving the construction of it to others. Wherever possible, he develops his ideas in drawings or sculptures, taking the thought through the materials from first move to finished work. This means that his sculptures are

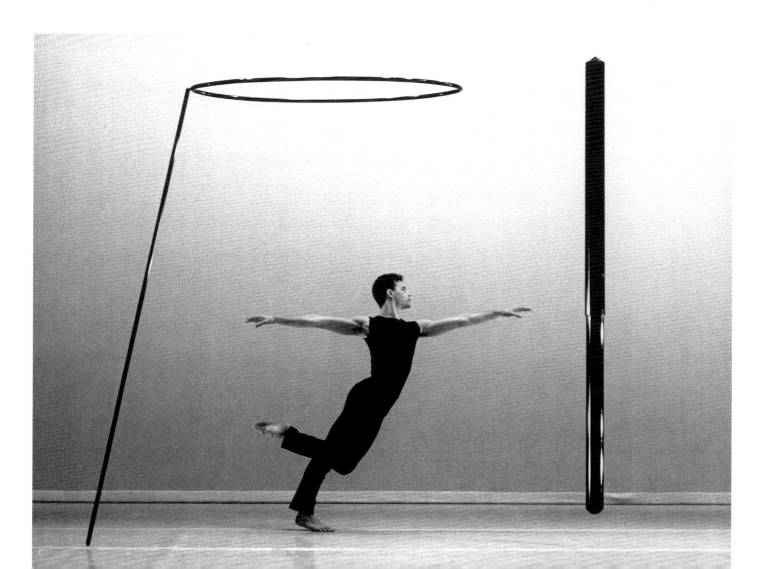

nearly always unique, rather than produced in editions, and although a good idea may be explored in different sizes, proportions or materials, it will not be replicated as a source of easy income.

I've never really wanted to become embedded in one technique. I've always used techniques which I feel are most appropriate to the ideas I want to work with at the time. The sequence really has been stone, clay, fibreglass, aluminium tubing, and currently wood and corten steel.

Did you like using clay?

I loved it.

Why didn't you carry on using it then?

The forms you make and the methods you use to make them change all the time, because the demands, the reasoning of the work changes. It would be false to carry on something that no longer had that necessity. I mean I miss aspects of my linear work: in purely practical terms, the transport was so easy. You think, why on earth do I now make things with such mass?

I carried on with clay for a while. I used to enjoy modelling those carpet forms, the ripples in them, the whole movement and slow build-up activity. I did miss it at the time, and I found at every subsequent change of working method, one does miss that activity. When I used to work in aluminium tubing, it was a rather slow and arduous process, almost like modelling in molten metal, and when that no longer became a necessity, I missed that activity too. It's almost like a historical thing where one craft, or one technique in history is superseded by another. Like the columns of a Greek temple which apparently were fluted to mimic the bundles of reeds that formed columns prior to that. Every technology seems to somehow adopt the forms of a previous technology, but you have to leave them behind in a way.

Primarily I like to make, it's part of my life really, the activity of making goes with thinking and dwelling on ideas. I can't envisage working as an artist without physically making things and developing an idea myself. So, in this big space [the studio], I tend to be on my own most of the time, and gradually forming my ideas by hand.

Drawing

Hall's early drawings, made in the 1960s, are quite informal and even scrappy compared to the deliberations of today, though they have a freshness and lyrical invention that is beguiling. They might show creases or coffee stains, but they've been carefully preserved as a source from which ideas could later be quarried. Drawing is central to Hall's practice. At least half of his work consists of drawing, a medium he favours far above printmaking (he's made very few prints) as a strategy for exploring his ideas.

The way I draw is fairly physical. Since the Sixties, I've incorporated charcoal with maybe pencil or gouache. But nearly always charcoal, which has for me a great physicality. But I don't make drawings

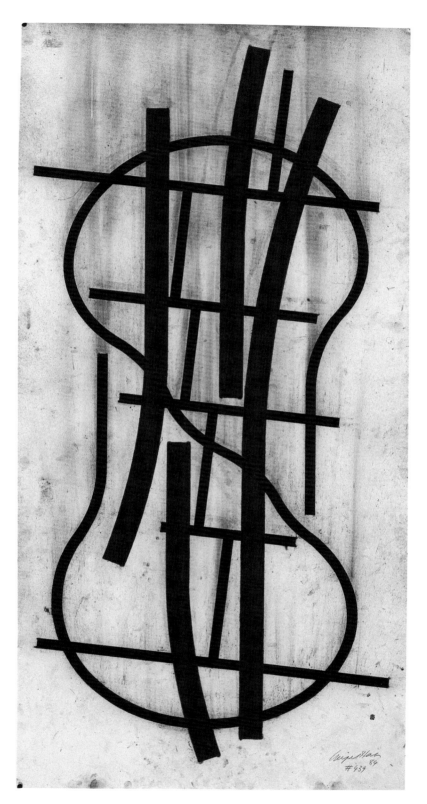

Drawing 439, 1984 Charcoal and pastel on paper 152.2 x 75 cm

toward sculpture, I make drawings as ends in themselves. And they exist in their own space, which isn't the same space that the sculpture exists in. It's a space which can be manipulated and twisted and dealt with quite differently from the physical world of sculpture that needs to respect gravity. I can use the paper as a very malleable surface on which to drop marks. And so I sometimes spend weeks making drawings (see p. 29).

How do you choose what materials to use?

I think it's a gradually evolving process. If I go through the drawings I have done, for years I would only use charcoal, and then there came a point when I wanted to lift the tone of a drawing. I was using charcoal a lot for its light absorbency. And then there came a moment when I wanted to do the opposite and I chose white, which then was modified into cream gouache, which has a slight sheen to it, so it would reflect light. I went to gouache for that particular reason, to do a particular job. The trouble with charcoal is that as soon as it's framed and glazed, the velvety absorption of light is lost.

I always carry a notebook, and fill one about every two months. It's sketchbook, diary, *aide memoire* – everything goes into it, and it's very useful because I also make notes of dimensions of sculptures, drawings (see pp. 32 and 33). So I can look back to any period, if I need to find anything. And in that I'll make landscape notes sometimes, ideas for sculptures developing. It's something I carry with me the whole time. About the last thing I do at night is go through my notebook and maybe make two or three jottings, ideas. And it's there first thing in the morning. Always with me.

Then there are drawings I make for sculptures, which are usually layouts for how to cut a form, or how two forms will fit together, very much working drawings. I keep them in a pile, but they gradually disintegrate, and every so often they get chucked out. But they're quite beautiful. In fact sometimes they're more intriguing than some of the finished drawings, because I tend to overlay forms on the same sheet, just for practical purposes, and the end result is quite interesting (see opposite and p. 34). And then there are the finished drawings, usually on a largish scale, anything between 56 by 76 centimetres, through to 70 by 100, up to 1.2 by 1.5 m. And then, in multiples of that, because I like very much making diptychs and triptychs.

You know how it is: you read a book when you're very young, and you pick up the same book again when you're past fifty, and it's a different book. It's the same book but you're reading it in totally different ways. And that's how it is with sculptural ideas. I dimly remember what I was thinking about in, say, 1970, but now I see it in a different light, and I can develop that idea in a different way. Or I can develop it now when perhaps I didn't pursue it then because I didn't know quite how I could take it forward.

I damaged my hand in October 1998, and I couldn't make sculpture for three months, so I decided I'd read a lot, and try and make some drawings. The resulting drawings occurred by taking books that I had enjoyed, which was an excuse to re-read them, and then trying to extract an image from them. (For example, Corbusier's *Modulor*, *Poetics of Space* by Gaston Bachelard, Milton's *Paradise Lost*, *Between the Woods and the Water* by Patrick Leigh Fermor, Walt Whitman's *Leaves of Grass*, Homer's *Odyssey* and *Tao Te Ching* by Lao Tsu.) So I would take a sheet of paper and some carbon

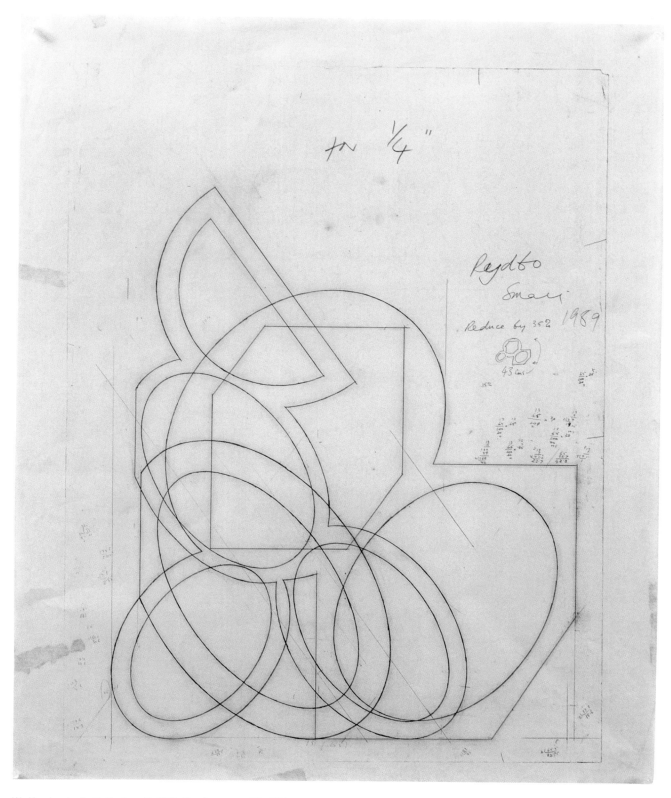

Working drawing for **Rydbo (small)**, 1989 Pencil on paper 73 x 59.5 cm

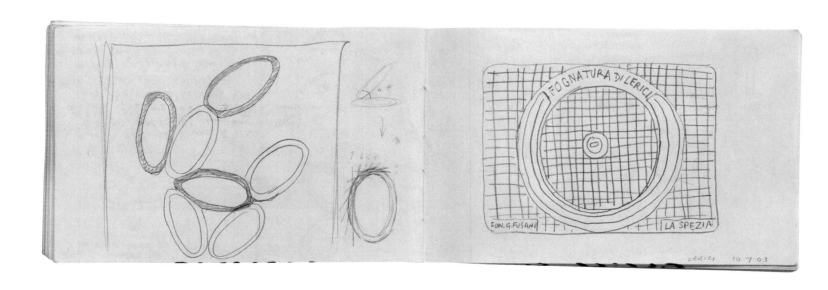

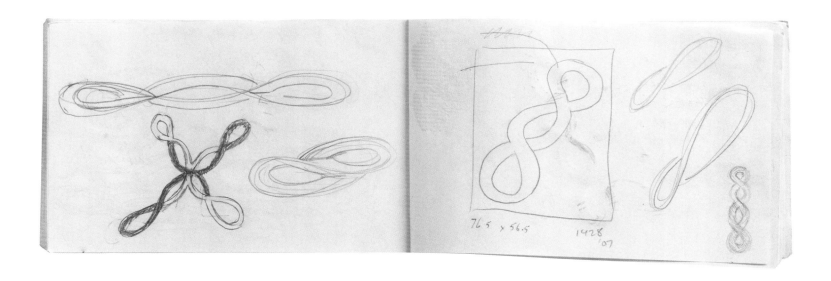

Sketchbooks
Clockwise from top left: 1988, 2007, 2007, 2003 11.5 x 35 cm

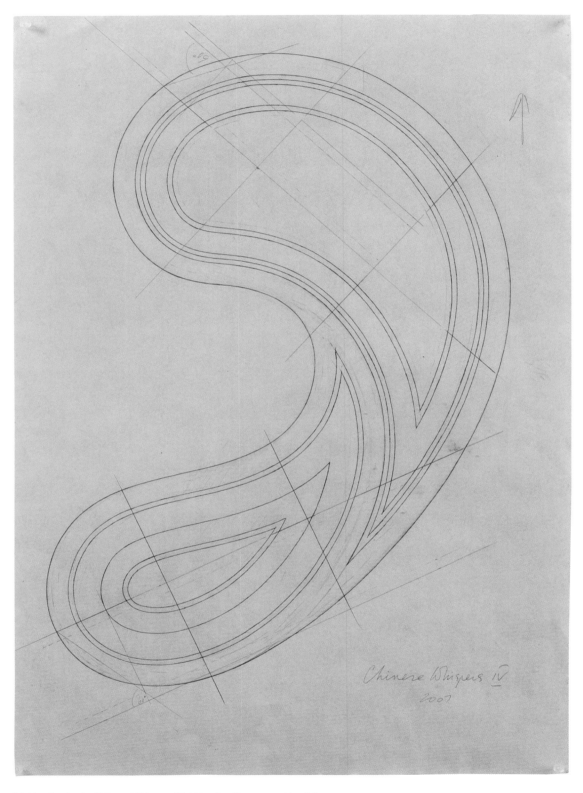

Working drawing for **Chinese Whispers IV**, 2007 Pencil on paper 84 x 59.5 cm

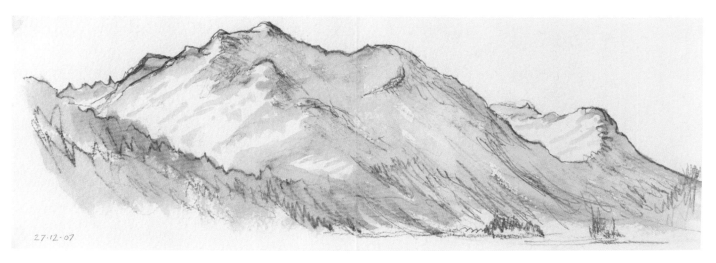

Piz la Margna, Engadine, Switzerland, 28/12/07 Pencil and wash on paper 15 x 42 cm

paper, and I would put those two under the page in the book. And then taking the first and the last letter of each paragraph, I'd use a ruler and a dried-out ballpoint pen, and draw a line connecting the first and last point. I'd work down the page, and then turn the page and do the same for the next right-hand page. (Because of the binding, it works best to use one side of the book.) And then gradually I build up an overlaid survey of the shape and structure of the paragraphs throughout the book.

How many pages would you use normally?

Probably in the region of thirty or forty. From this seemingly limited system a great variety of images resulted. Especially when you come to poetry where you get a rhythmic response to the stanzas and verses. Diagonals have been a regular feature in my work and I was intrigued by the possibilities of extracting a structure from the horizontal and vertical coordinates of a book (pp. 120–1).

Travel
Wherever he travels, Hall tends to make observational landscape drawings which he rarely exhibits. Travel is intimately linked to work, and the artist will primarily visit those countries where his work is exhibited, deriving refreshment and inspiration from the visual stimulus of a new place. In addition, Hall and his wife, the painter Manijeh Yadegar, have established a pattern of spending Christmas and New Year in the Engadine in Switzerland, near the Italian border, primarily to walk in the landscape and to savour its peacefulness.

It's a beautiful location, with a view across the lake towards Maloja and Italy one way and towards Fex Valley the other. I walk and make a lot of drawings of the landscape (see above). These don't

Larch Twigs in Snow, 1989 Pencil and wash on paper 17.5 x 24.5 cm

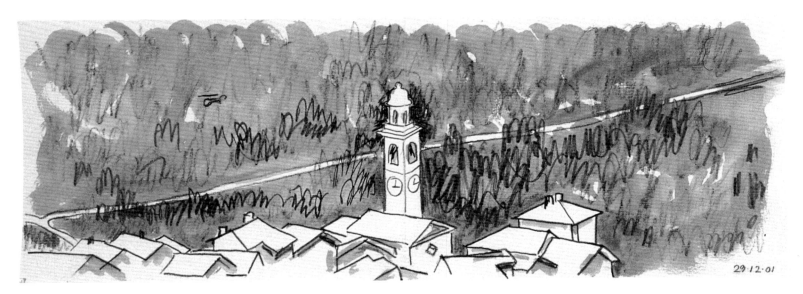

Soglio with Helicopter, 29/12/01 Pencil and wash on paper 15 x 41.5 cm

translate in any way into other drawings or sculptures. Not directly, but I think indirectly they must do. Certainly a lot of pieces of recent years have come from this area. I draw either wide vistas or very detailed views. I remember one year all I drew were the needles from fir trees, and how they dropped on the snow. Or how the twigs from larches had fallen, and caused hollows to be formed in the snow around them, and how these black spiky twigs sat within these concavities on a white expanse (opposite above). This is what this type of landscape does, it tunes up one's vision, rather like the desert did, very similar. I've been once in the summer, and I wouldn't want to go again, it doesn't have that same quality for me. It needs to have a good covering of snow and ice, and good light. Even in winter you do get quite good sun, a wonderful combination of light and shade, and strong shadow, a lot of the landscape distraction whited out. And not too many people. It's the only place I go back to on a regular basis.

Because it's often bitingly cold, you can't actually spend too long drawing, so my drawings tend to take no more than twenty minutes at a time. I use soluble pencil and wash, and often the brush is freezing, literally with ice forming on the page.

There's usually a pilgrimage to a little town called Soglio, which is even nearer Italy. You drop down the Maloja Pass in the Val Bregaglia, and down a very narrow valley, past Stampa where Giacometti was born. Soglio is a hill town, very narrow streets, and a wonderful view of a very special mountain range, of quite angular, crystalline shapes, very good for climbing apparently, and you can walk through the woods with incredible views. It was made famous by the Italian-Swiss painter, Segantini. And Giacometti's father and uncle and the whole Giacometti family painted in this area.

I make drawings there and we usually go there at least once every trip (opposite below). It's set amongst sweet chestnut forests, and you can look down into the distance towards Italy. It's a beautiful place, quite, quite magical. Since 1994, I've called a lot of sculptures *Soglio* (see p. 41), a whole series named after it, mainly because of my fondness for the place, but also because there's something about the structure of the mountains and the surrounding quality of the place that maybe affected the open truncated cone pieces I made.

But it's not a direct reference?

No, not at all. This happens a lot. When I name a piece, it might be recognising something in the piece that relates to a place, or it might be that the place has quite a strong effect on me emotionally, and therefore I mark it by giving my sculpture a place name as its title.

Or it could be perhaps a similarity of spirit?

That's true. *Hidden Valley* refers to the Fedoz Valley in Switzerland. But I don't think you would automatically think of landscape. I mean there aren't elements within it that suggest that. It's a wall sculpture in wood, composed of two truncated, elliptical cones, and one elliptical cone fits onto the wall with its narrow aperture out, and the other fixes to that narrow aperture the other way round, so its wide mouth is out, which draws the eye into a darkened interior.

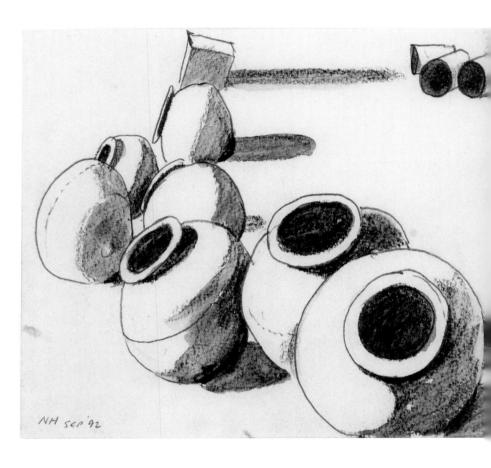

Landscape has a dance and a movement as you move through it. And elements within it displace themselves in different ways in relation to one another and to you, which I find closely paralleled in how I make sculpture. So sculpture for me is like moving through space, space that's made visible by mark-making forms, open forms, and how those elements of open forms move amongst themselves as you move with the sculpture. It's that sort of relationship of form, space and the observer. As with landscape, sculpture has a stillness until the observer moves.

I think one element within the *Soglio* pieces came from a group of big ceramic pots I saw. I was driving through the mountains in central Cyprus in the early 1990s, and I caught a glimpse in a village of an open dusty square, with about ten or twelve big olive oil vessels in it. They were huge – perhaps six foot in diameter. I stopped, and spent a while drawing these spaced-out arrangements of giant pots. In the background were a group of oil drums. And I just loved the relationship of the two, these ancient rounded forms in the foreground, and in the background these very modern forms doing very much the same thing, trapping the shadows, holding spaces and relating one to another. That is such a vivid memory. Shadows are such a strong part of the way I see. I find it very difficult to draw if there's poor light. I need good shadow and delineation: the shadow actually establishes the form within its surrounding space (see above).

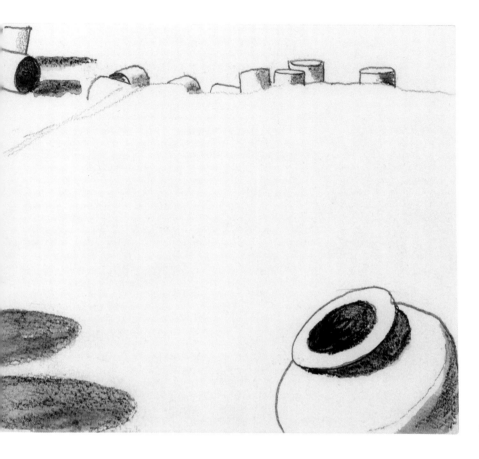

Cypriot Pots, 1992 Pencil and wash on paper 15 x 41.5 cm

Favourite Forms

The cone and the inclined beam, very often taken in conjunction, are at the heart of some of Hall's finest sculptural ideas. These basic forms are not easy to exhaust, and Hall continues to elicit visual magic from circular or elliptical sections, wedges and bars. The references are many and diverse: lens and strata, bridge and funnel, the pollarding of trees, boundaries and apertures, semaphore telegraph (think of Ship-to-Shore signalling) (p.111). But at least three-quarters of the appeal of these works is formal and resides in the subtle visual music they conjure.

I don't know how one could explain the diagonal, or the sort of obsession with particular angles. Of course, it might be just fanciful, but I was always very keen on sailing. And, if I think of the sea, I don't think of a still, horizontal calm sea, which is what everything settles back to, in the absence of wind and waves. But I think of a movement across that horizontal – could be from the masts of boats. I did a lot of drawing of boats when I was young, and of the way a sailing ship tilts into the wind. I wonder whether it comes partly from that. But it's certainly something which has existed quite consistently in my work, both in the drawings and the sculpture. Also, often in the way a sculpture sits. It might hit the ground in a particular way which results in certain members at a particular angle to the ground.

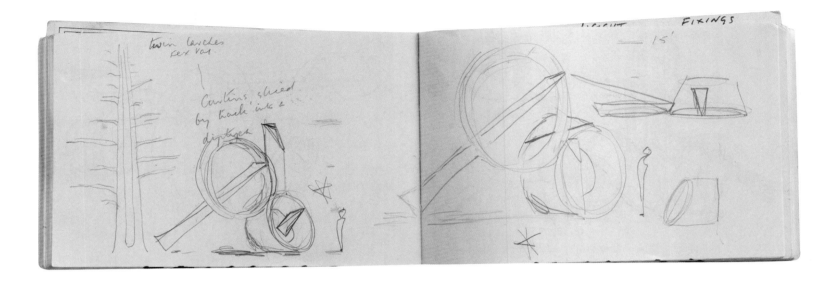

Sketchbook
Drawing for **Soglio**

In Bristol I was making sculptures that were like water tanks or gas cylinders, which is to do with a skin or a surface which holds in something of great pressure. But my interest really in these hidden spaces, or spaces which are concealed where the imagination could play, certainly is something which has continued in terms of the work I make now, where the void or a hinted-at space is as important an element as that which is contained by the substance or material of the sculptures or drawings.

I also like the idea of transparency in sculpture, the ability to see through elements of it, and see the space beyond. So that actually the sculpture encompasses or borrows the space of the place in which it's set. It frames a part of the view, and allows one element to be seen through another.

Soglio (Schoenthal) is a massive piece and not exactly what one would call transparent by any means because it's got solid walls of nine tons, but actually it does create a circular window. So it becomes like a lens. You can actually see through the sculpture, and it focuses one's vision onto the space beyond (opposite).

I like resolution to situations, and I like precision in relationships I suppose. I think that shows in the work I make. I don't like indistinct elements fusing into something else. I do believe that the way one form touches another is very important.

And clarity.

And clarity, yes. I equate that with a certain honesty. I like to be able to make my work with as much honesty as possible, so you don't fake it. This shows itself most clearly when I want something cast at a foundry. I fabricate most things myself now, I have a couple of craftsmen who work with me on the big steel pieces and they know me and they know how I want it made. But often, when I was going to a foundry with the idea, or the wooden pattern of what I wanted to make, what they looked at and saw was something very simple. They'd see a few sharp-edged geometric forms, and they'd look

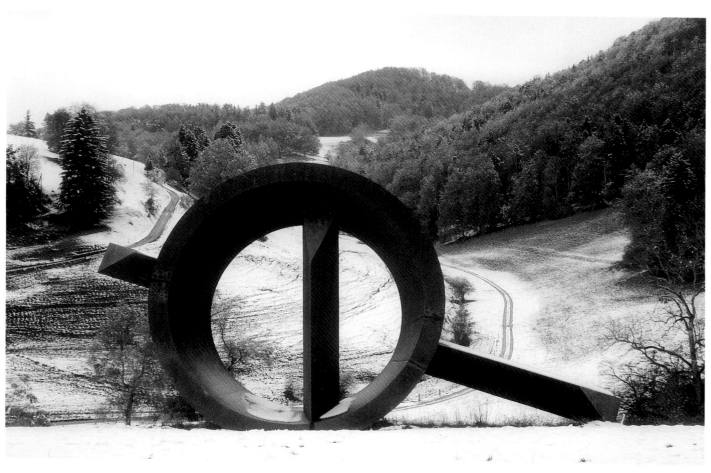

Soglio (Schoenthal), 1994
Corten steel
550 x 1100 x 308 cm

at it and they'd say, 'Well that's no problem.' And I'd leave it with them. I'd go back later, and I'd find something which was a travesty of what I'd left, simply because they were used to casting work that had a lot of modelling. Most objects one thinks of in cast bronze have a great deal of texture and undergrowth where you can hide things. You can hide a hell of a lot in texture, you know. With my work, there's nowhere to hide anything, which is why I'm not very good at working with an assistant. So I do tend to make everything myself that I can make, and those things I can't make, I find people who can learn to do it the way I want it to be done.

Is the work autobiographical in any way?

I suppose it is, you know, and maybe even in its structures sometimes I feel it echoes some of one's own body movements and awkwardnesses. When I was a kid, I was obsessed with the idea of balance.

Hall is emphatic, however, that his work doesn't reflect the emotional weather of his private life.

My routine of working is so strong, I carry on irrespective of what's going on around me. Although the work is abstract and often geometrically abstract, I think it is emotionally charged, and that changes at different times. Certain events will obviously have an influence on the work, but I am able to treat it as a discipline. I do find work a refuge: if times are difficult I will immerse myself in it. I suppose a lot of people do this. But I certainly don't use it as a release from specific problems in life.

Sculpture and the Public

Hall's sculptural priorities run like this: firstly to make good work, secondly to have it shown, thirdly to try to make a living from it. Perhaps not always in that order, but urgencies change with age and circumstance. He does believe that there's no point making a lot of money out of art if you're not fulfilled by what you do, nor is there any use making the greatest art if no one ever sees it. But these days sculpture in public places has its own set of problems.

There doesn't seem to be any way round it, people think of sculpture as an adventure playground, which is a great shame.

They never used to.

No. I know, they didn't. I don't know what's happened. It seems as though sculpture has to be participated in physically rather than walked around and looked at. I mean a lot of sculpture's for touching, you can't deny that, therefore I suppose the step beyond that is, it's big enough, it's climbable-on; but it does seem a bit unnecessary to me.

I used to make sculptures which were very delicate, and, in the Sixties and Seventies, I made hanging or wall-mounted pieces which were an irresistible temptation for people to push and swing (see opposite). And I don't like moving sculpture; I like sculpture which is still. I like sculpture to move and reveal itself when you move. And the sculpture becomes alive and active, like a dance, and it's still when you're still. I prefer that to sculpture which is kinetic, though there are exceptions. I do love Calder's work, and a few others, but I wasn't very happy when people moved my sculptures in those days. Now I make more robust pieces, but I could do without people climbing on them.

And Landscape

One of the things Hall admires about the American poet Hart Crane is his grasp of what might be called eternal truths about the world as we know it: for instance, the meeting point of the natural world and the manmade – such as the way a bridge spans a river landscape. That conjunction of man and nature has long been a fruitful inspiration for Hall. Thus his wood pieces contain the marks of their growing (the grain and eye of the wood), and his charcoal drawings are covered in smudges and fingerprints and dust (the marks of making), from which his rather pure forms emerge.

I would say my work comes out of a sort of landscape tradition, without a shadow of doubt. In that, I would include the urban landscape with all its hardware and visual stimulus.

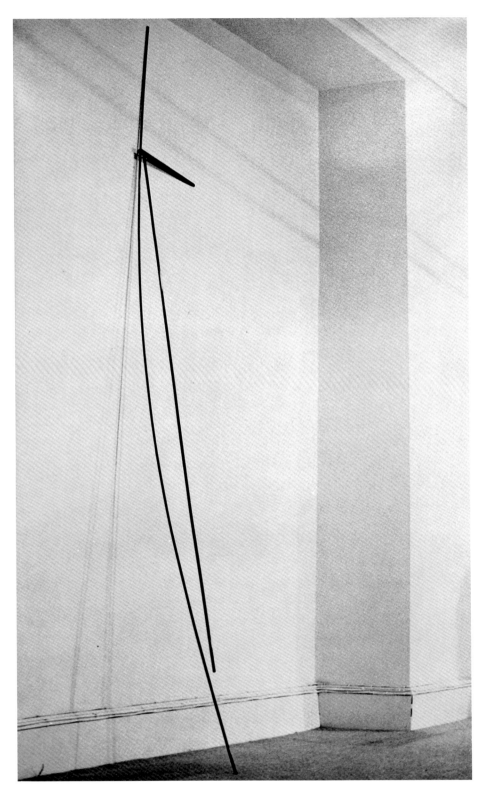

Pocket II, 1972 Painted aluminium 305 x 76 x 53 cm

I know how much you like Cotman, for instance.

Yes, I do, I love that artificial depiction of landscape, because in a way it's a precursor of Cubism. It's that sort of analysing of form and playing with landscape structure which I really enjoy. But I don't want anybody to start trying to see landscape in my work directly, although I treat sculpture, or even drawing in a sense, like a walk-in landscape. Walking and driving are two things I enjoy, I suppose, for different reasons.

Although I did a lot of walking in desert areas, it was a much smaller scale of moving. Very different to the vast distances of driving... I mean I drove across America twice each way, and many times north to south, and in the western states, long journeys with very little else on the road. You could really get your teeth into it. It does induce a meditative, thought-provoking state, where space and the varying speed of elements play a part: things close to the road moving at one speed, and distant mountains or hills moving at a slower rate, and gradually things unfolding and being revealed. I do develop a lot of thoughts travelling.

Do you think at a different pace while driving, or, does the mind adjust to the fact that you're moving at speed? There's another theory quite opposite to yours, that the mind works best at walking pace.

It probably works best, yes. But other things happen in different ways too. I tend to build my ideas at different times. One of my first memories of building an idea was not driving myself but being driven by my father when I was a child. We used to go to Cornwall, and in those days it was quite a long drive. It's the earliest memory I've got of actually conceptualising an object rather than getting up and doing it. In my mind I built myself a little wooden car, I must have been about seven or something like that. I designed it in my mind. It's funny isn't it, I can remember this so clearly, how I would put the axles and the wheels on, how I would make those rotate. I was probably too young to physically handle a saw and a screwdriver, but I can remember designing this little prototype car.

But when walking, I tend to be more involved in the direct experience of what's there. Driving seems to allow a more abstract state, which isn't directly about what's around one, whereas walking up in the mountains is very much about seeing and looking and dwelling on places I've walked through many times before, seeing them in a slightly different light, or stopping to make a little drawing of a view.

Certain landscapes have made strong impressions on me, and the west coast of Scotland is one. Its shape and its structure have imprinted themselves on me and made a big impact. I found the landscape of the west coast much more elemental [than Cornwall, for instance], the way that the mountains drop into the sea and the peaks are often obscured by cloud (see opposite). Landscape is fascinating, because although you can touch it, like a bit of earth or a rock or something, the whole experience of that landscape is somehow intangible. You know, you build it up in your mind, like a concept. And yet one tends to think of it as being the most physical thing, a landscape, but it's not, it's beyond one's reach, always. Just as the horizon moves away the whole time.

Hall aims to achieve a progression from the physical to the spiritual in his work, the kind of development he identifies in the paintings of Claude Lorrain. For an abstract sculptor he is involved to a surprising degree with landscape and the human presence, a duality of interest that has existed since his earliest work, and which with the passage of years has only become further distilled. The continuity of his interests in space and form is clearly evident from the briefest of retrospective looks at his career. Hall is deeply involved with the poetry of objects, with things made and things discovered. His art is intensely personal and individual. In this age of rampant consumerism, when the contemporary art market has degenerated into a feeding frenzy, it's an attitude that can only be admired and saluted. Nigel Hall employs not only a quality control but a quantity control also, and his work grows in stature because of it.

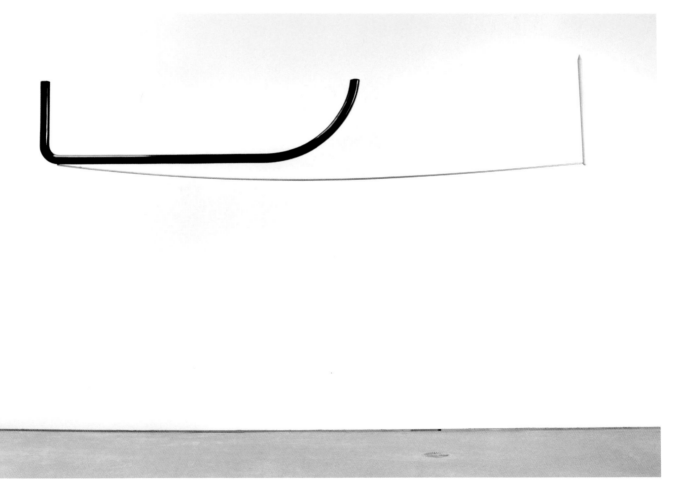

Plateau Marker, 1971 Painted fibreglass and aluminium 102 x 412 x 7.6 cm

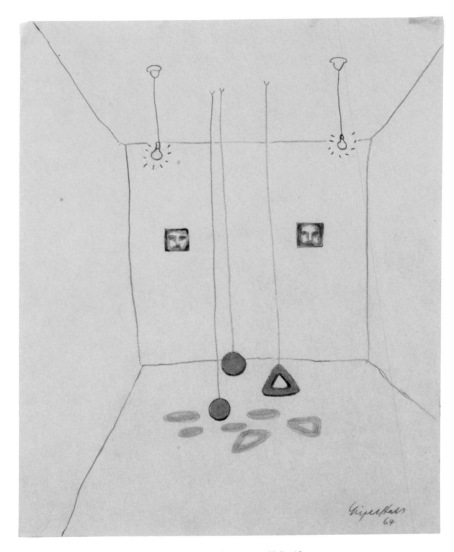

Experiment with Pendula, 1965 Pencil and pastel on paper 22.8 x 18 cm

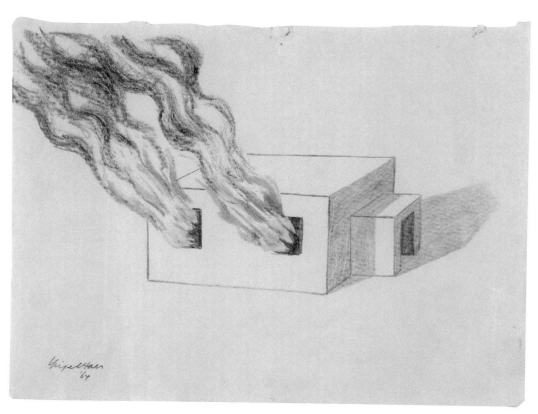

House on Fire, 1964 Pencil and pastel on paper 17.5 x 23 cm

Lone Figure with Balloon, 1965 Painted fibreglass, wood and metal wire 33.6 x 24 x 20 cm

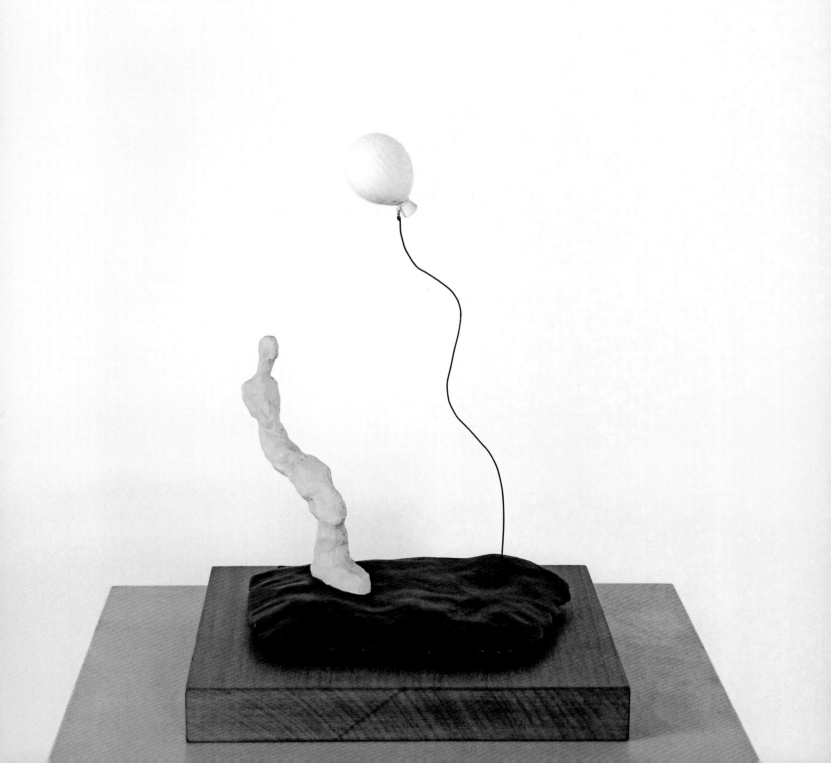

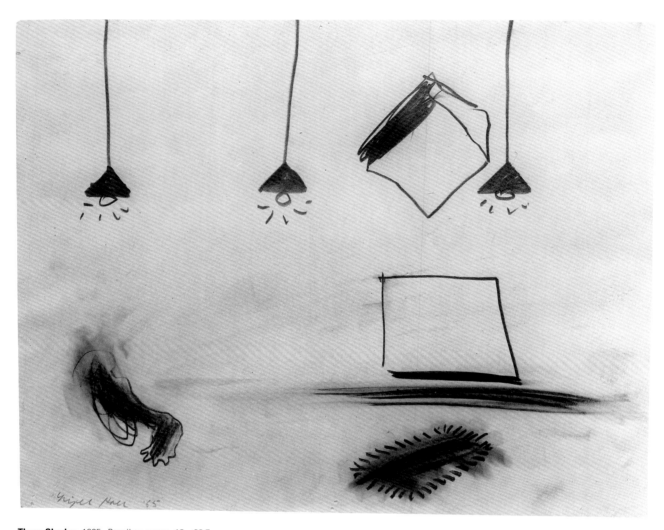

Three Shades, 1965 Pencil on paper 18 x 22.7 cm

Freeze I, 1965 Painted fibreglass, perspex and steel 76 x 51 x 51 cm

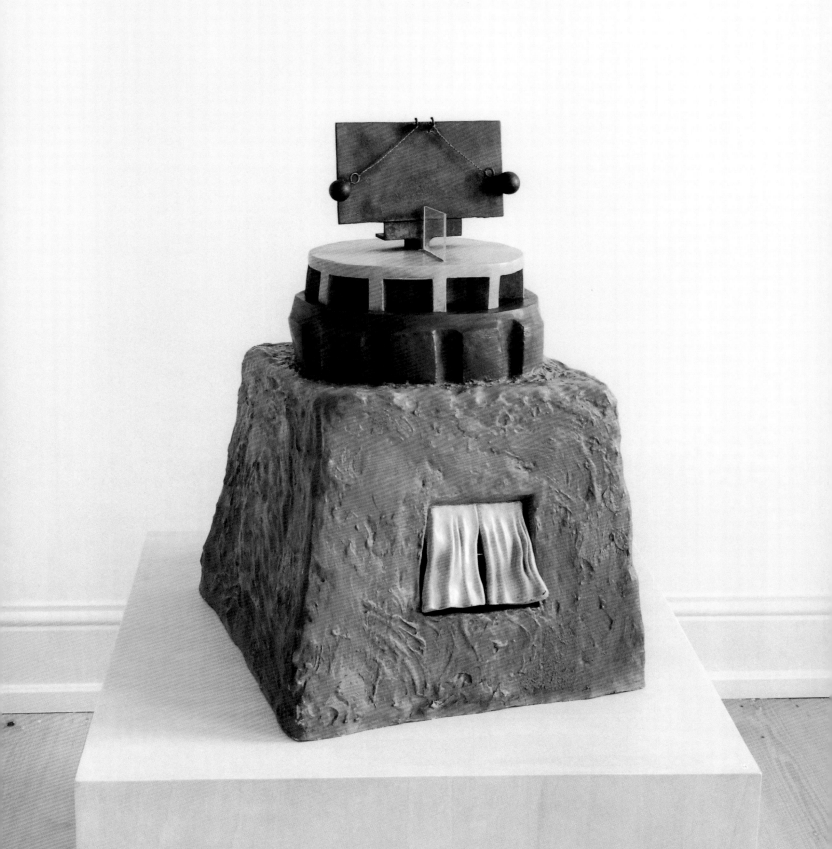

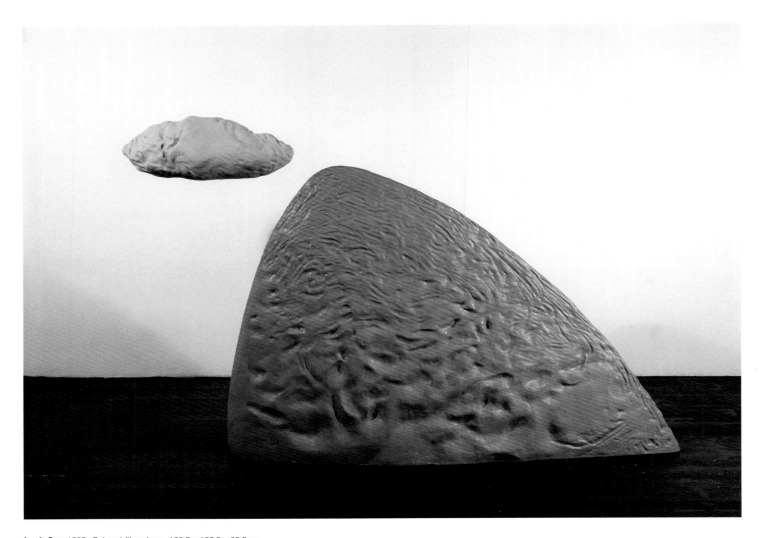

Look Out, 1966 Painted fibreglass 129.5 x 190.5 x 30.5 cm

Magnet, 1966 Painted fibreglass 270.5 x 409 x 198 cm

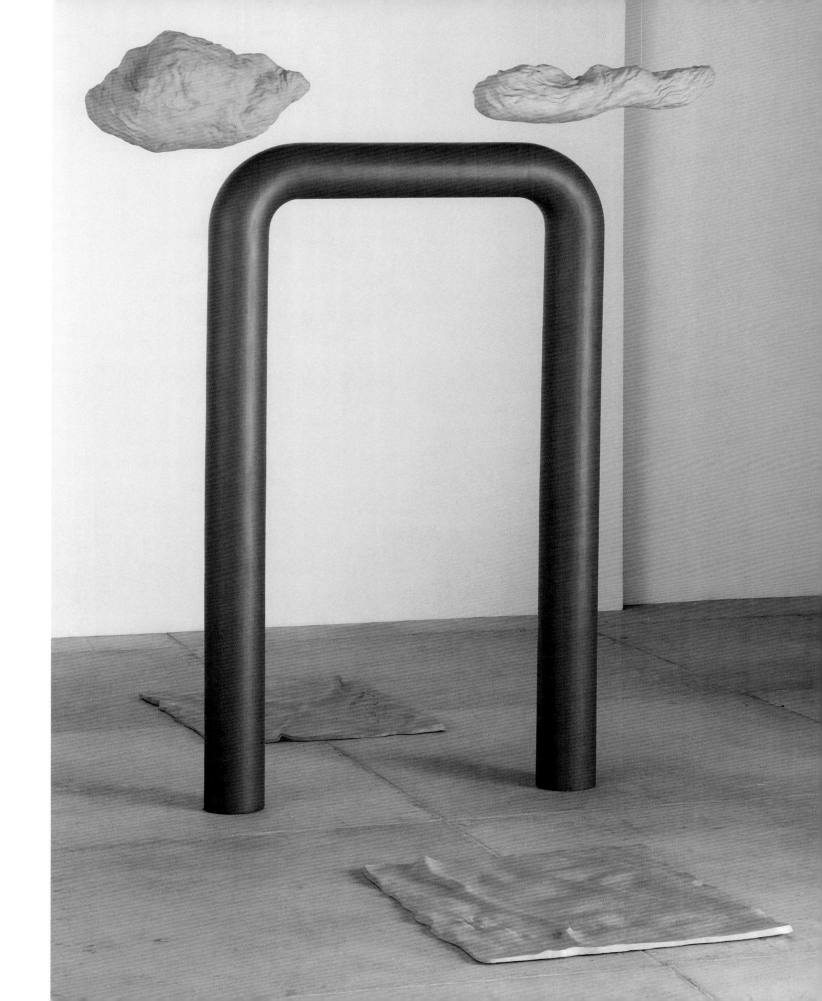

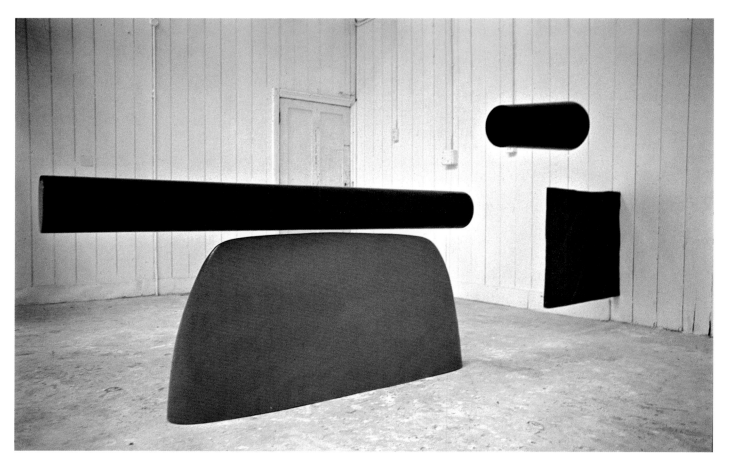

Wide Divide, 1967 Painted fibreglass Approximately 150 x 370 x 30 cm

Great Ledge, 1967 Painted fibreglass and steel 168 x 152 x 123 cm

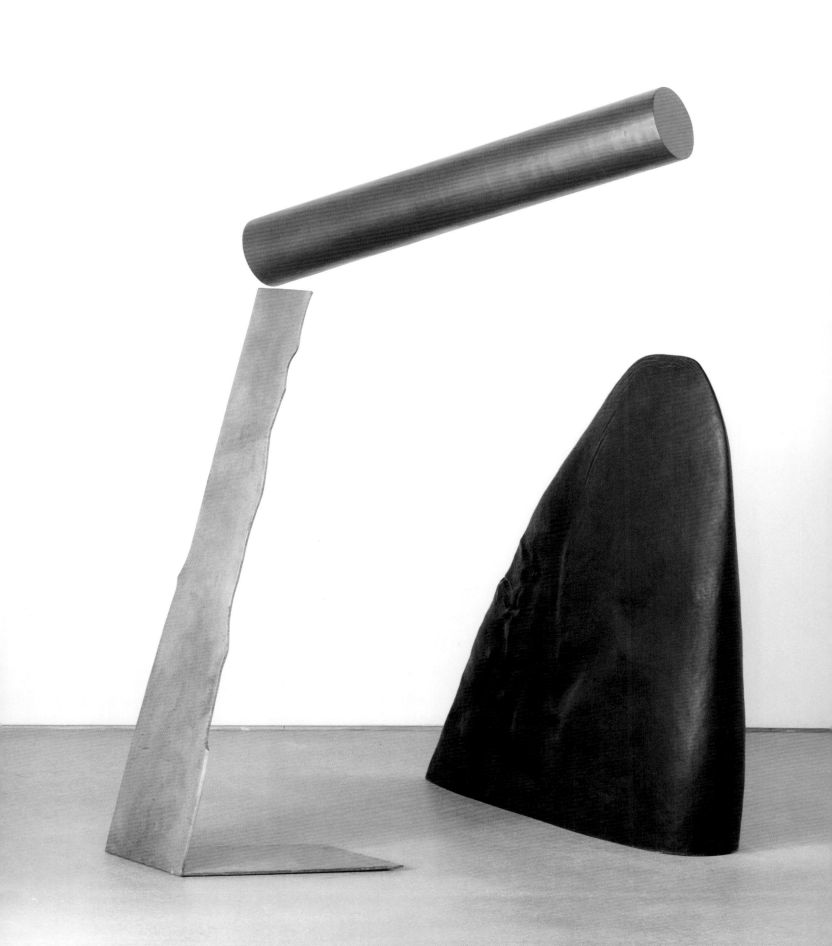

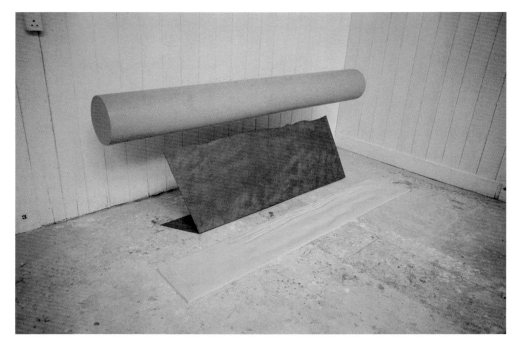

Humming Hill, 1967 Painted fibreglass and steel 94 x 244 x 91.5 cm

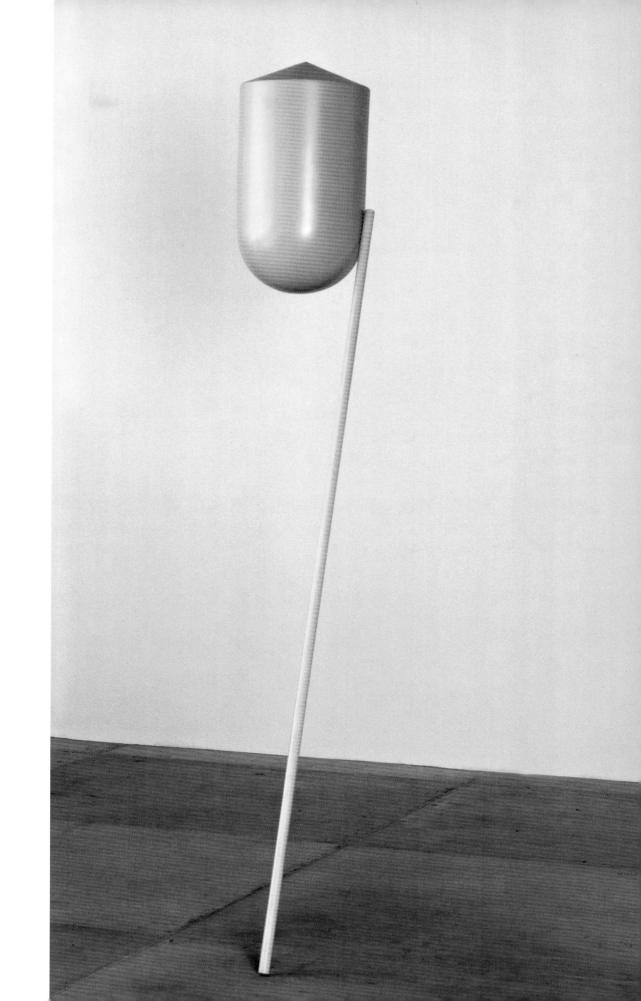

Tower, 1968
Painted fibreglass and aluminium
280 x 97 x 42 cm

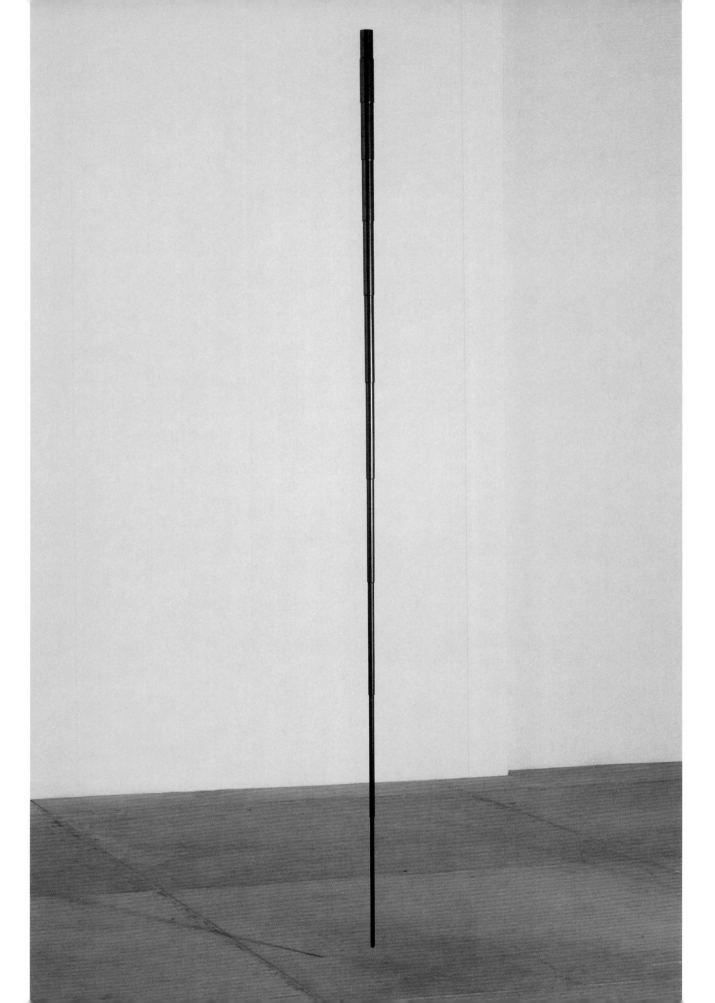

Spike, 1970 Painted aluminium 254 x 4 x 4 cm

Soda Lake, 1968 Painted fibreglass and aluminium 268 x 265.5 x 61 cm

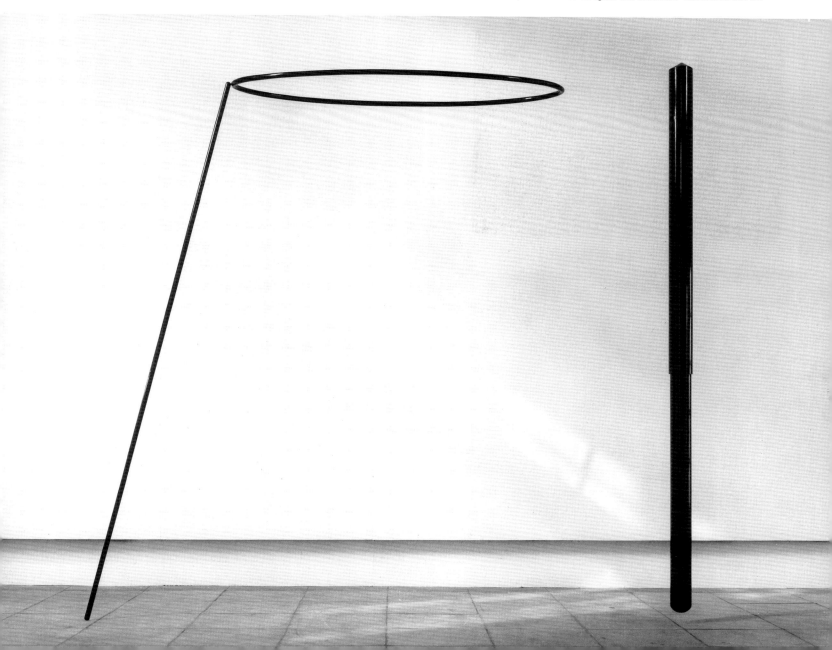

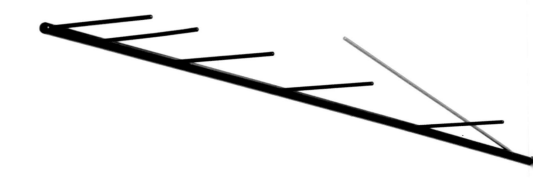

Crest, 1973 Painted aluminium 44.5 x 393 x 68.5 cm

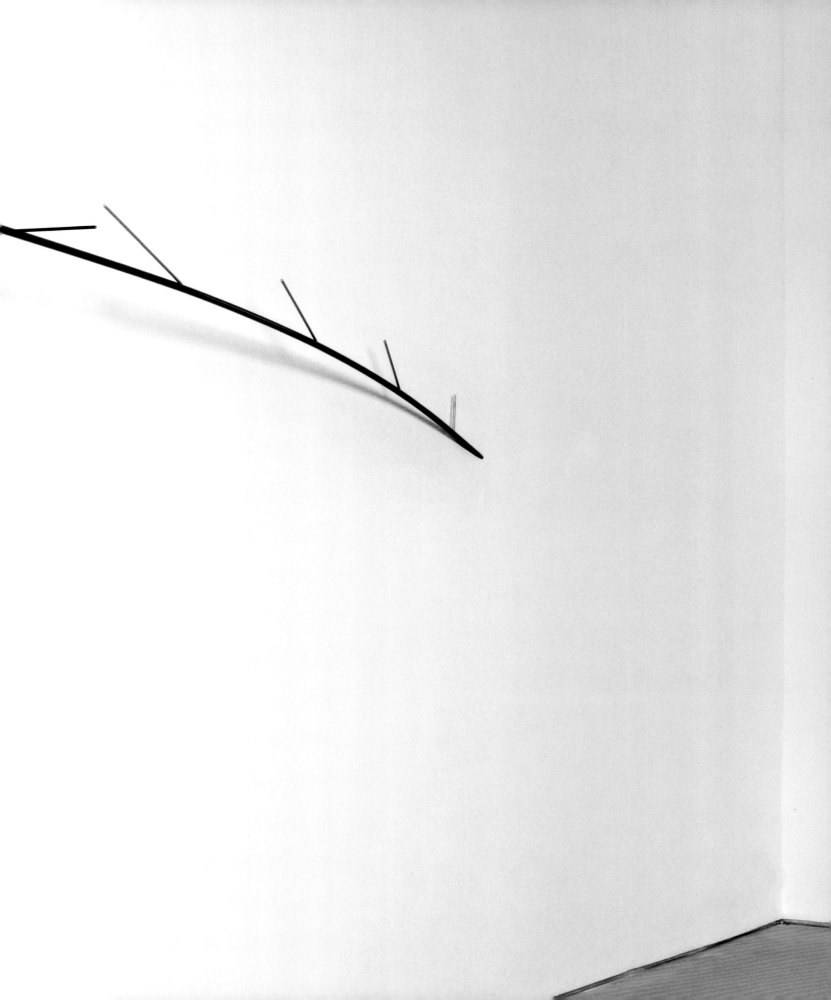

Untitled, 1972 Charcoal on paper 56 x 76 cm

Untitled (Ragged), 1972 Charcoal on paper 56 x 76 cm

Two Ellipses, 1974 Charcoal on paper 56 x 101 cm

Two Bars, 1974 Charcoal on paper 74 x 101 cm

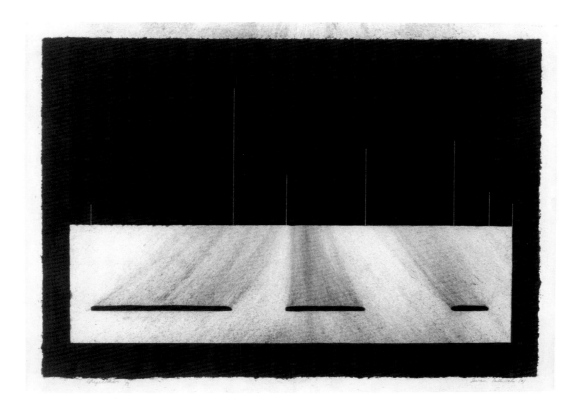

Untitled, 1973 Charcoal on paper 55.8 x 76.4 cm

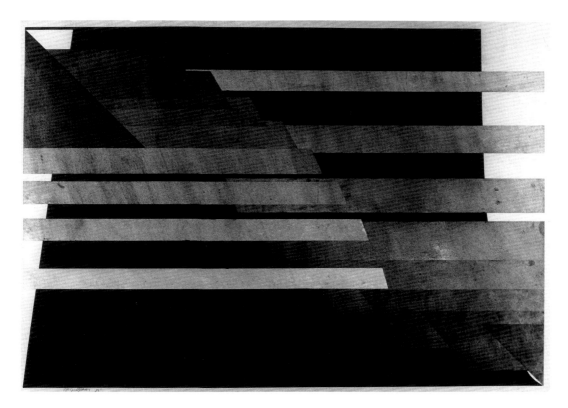

Untitled, 1975 Charcoal on paper 56 x 76 cm

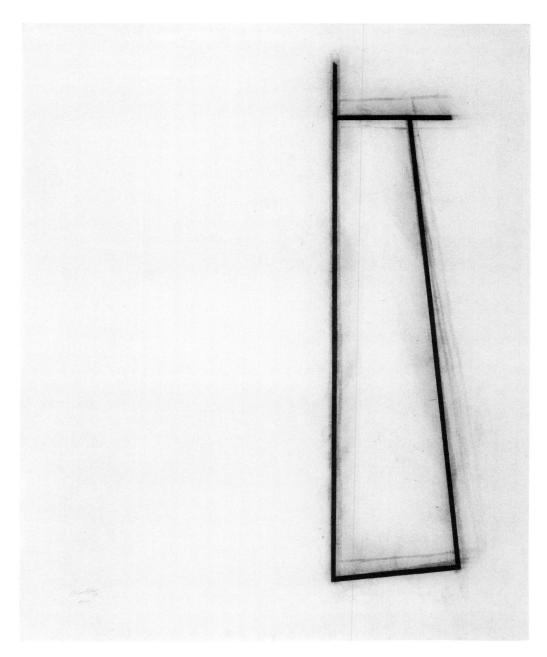

Drawing 108, 1979 Charcoal on paper 153 x 122 cm

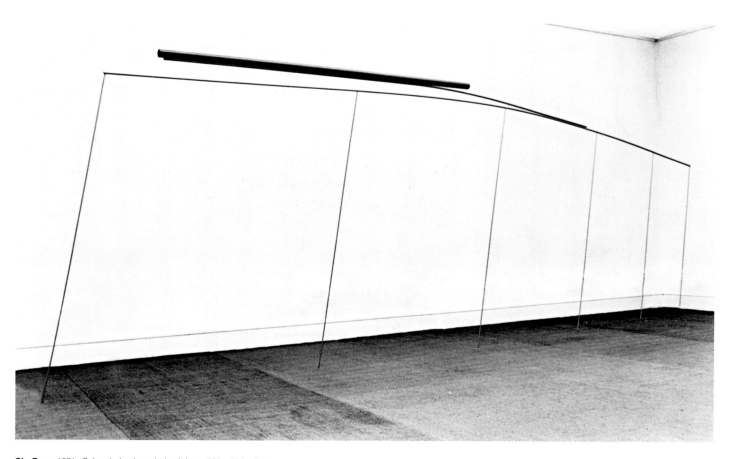

Six Bars, 1971 Painted plastic and aluminium 335 x 884 x 8 cm

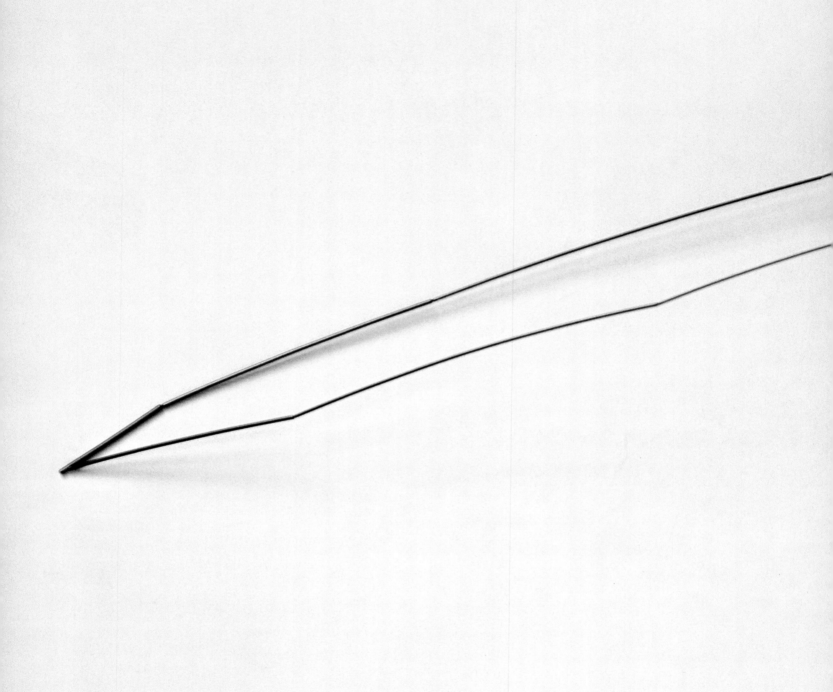

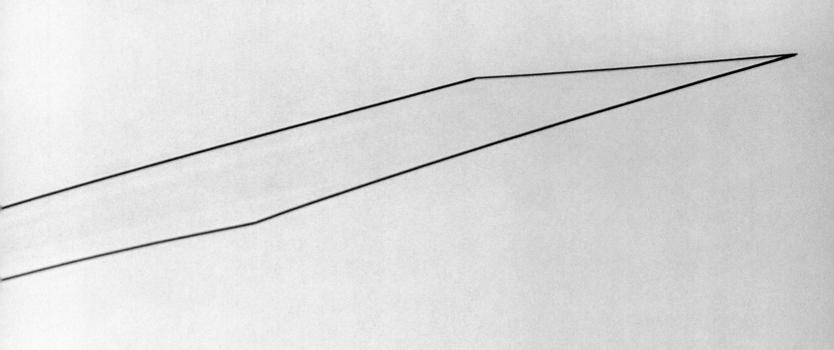

Precinct III, 1975 Painted aluminium 115 x 395 x 82.5 cm

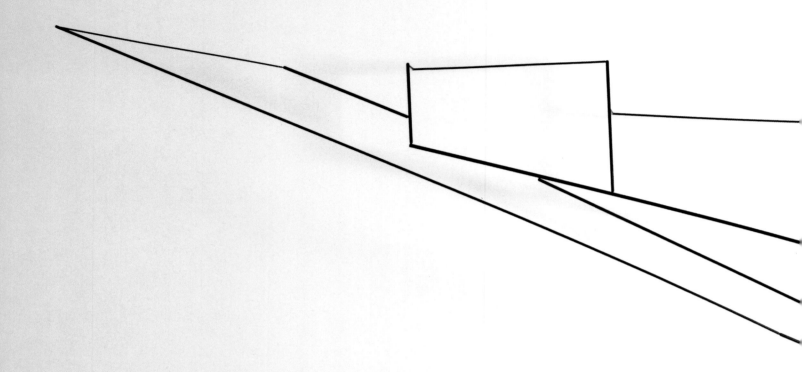

Black Minus, 1975 Painted aluminium 258 x 410 x 125 cm

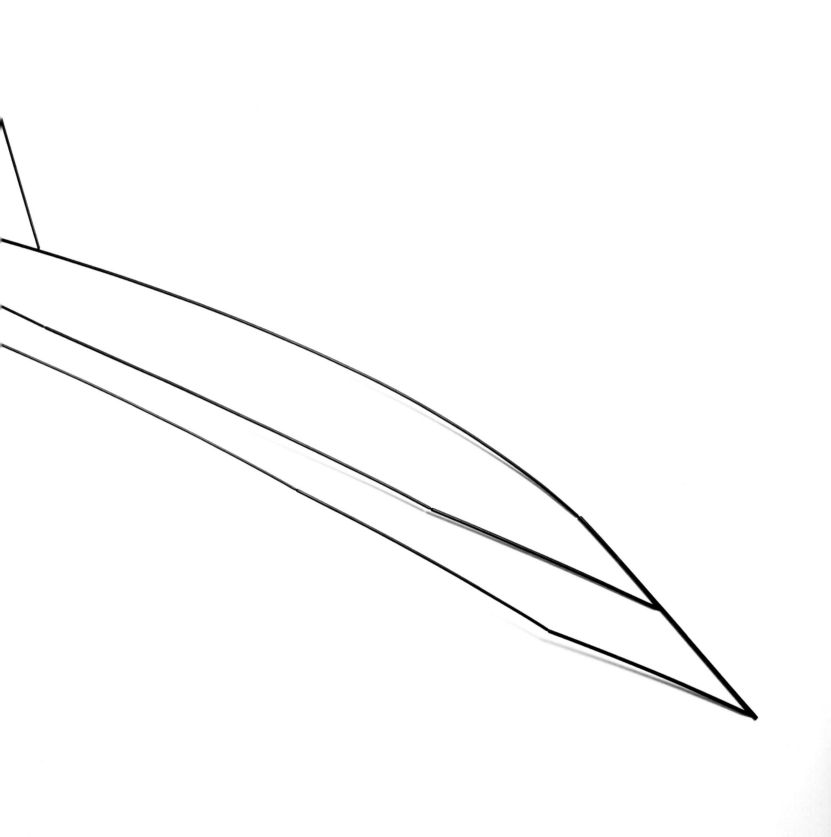

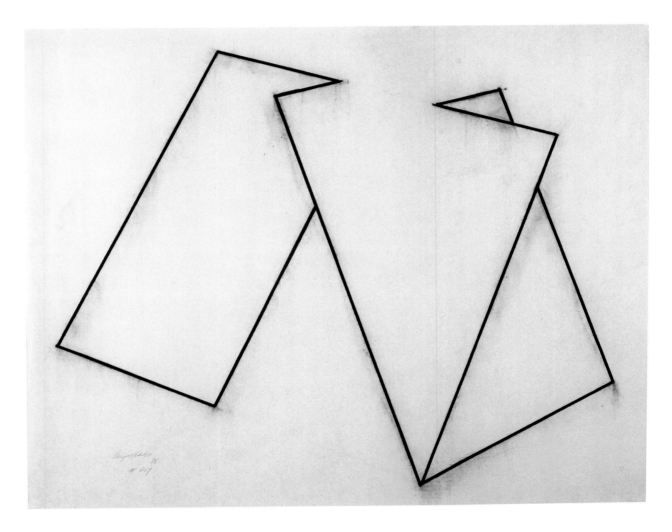

Drawing A27, 1979 Charcoal on paper 122 x 153 cm

Four, 1976 Painted aluminium 252 x 222 x 84 cm

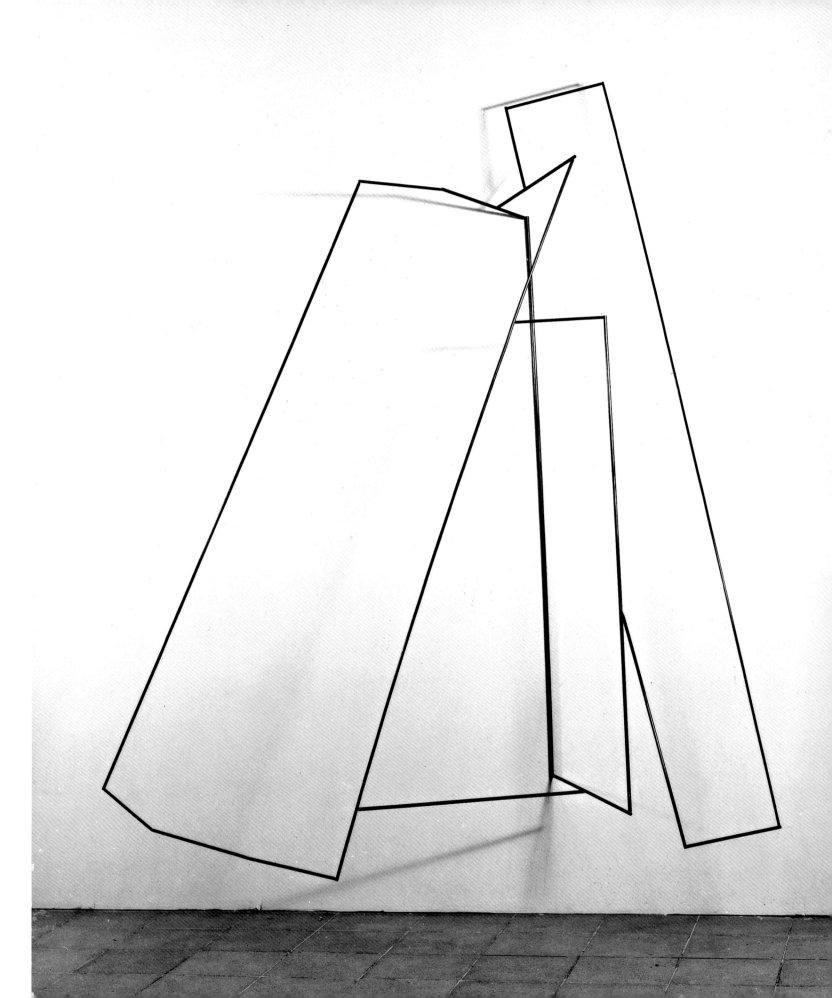

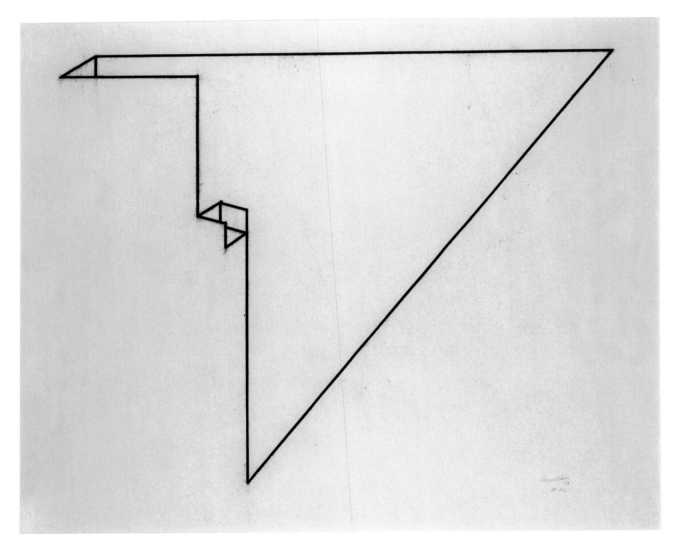

Drawing A12, 1977 Charcoal on paper 129 x 153 cm

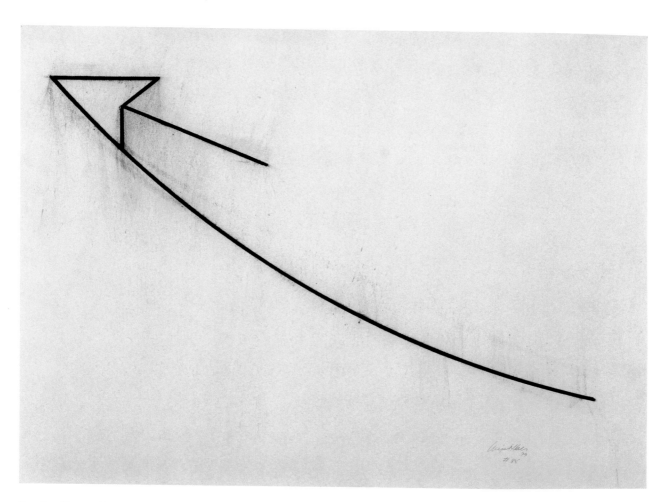

Drawing 85, 1979 Charcoal on paper 76.3 x 101.5 cm

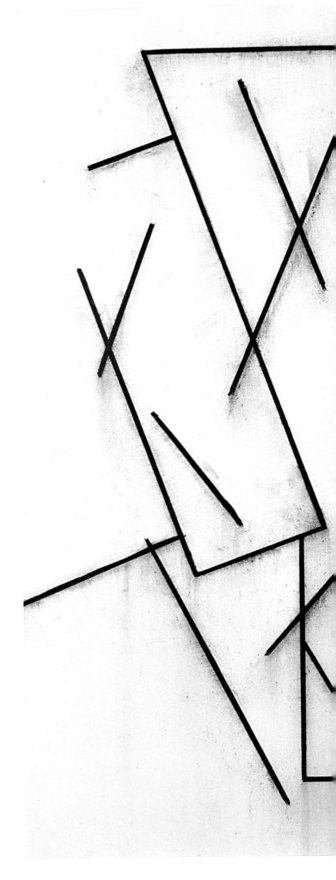

Drawing A33, 1978 Charcoal on paper 130 x 155 cm

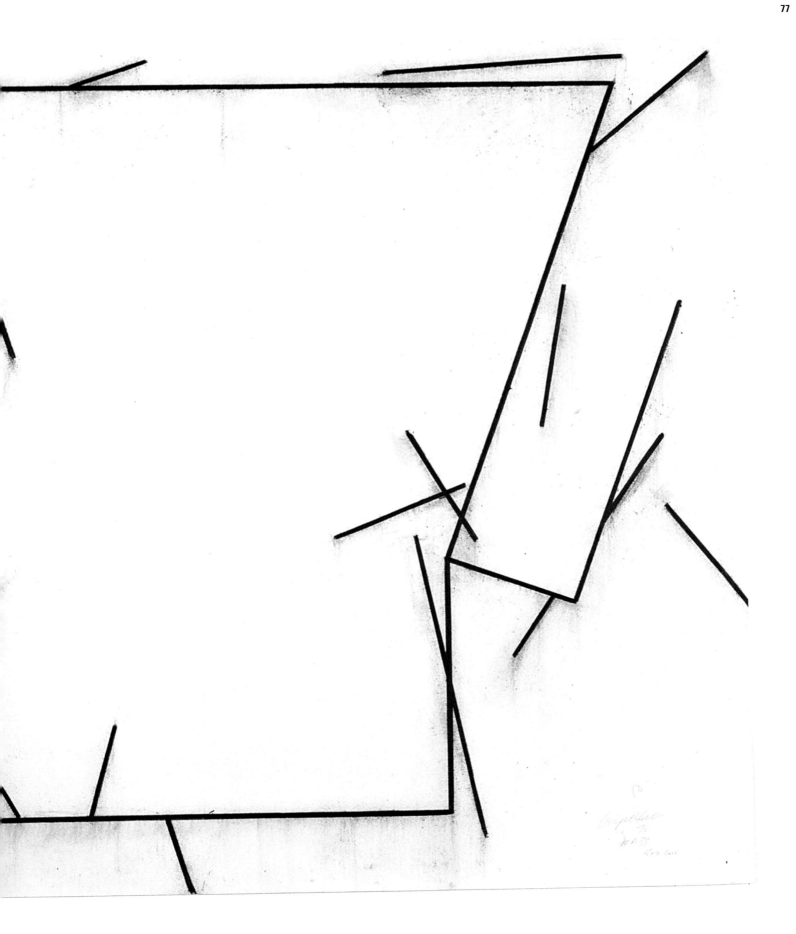

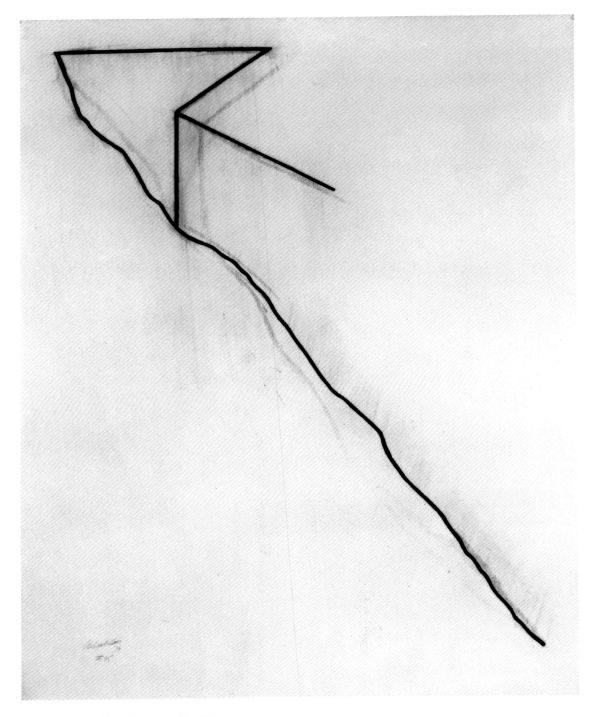

Drawing 95, 1979 Charcoal on paper 152 x 122 cm

Key (stone), 1979 Painted aluminium 59 x 160 x 53.5 cm

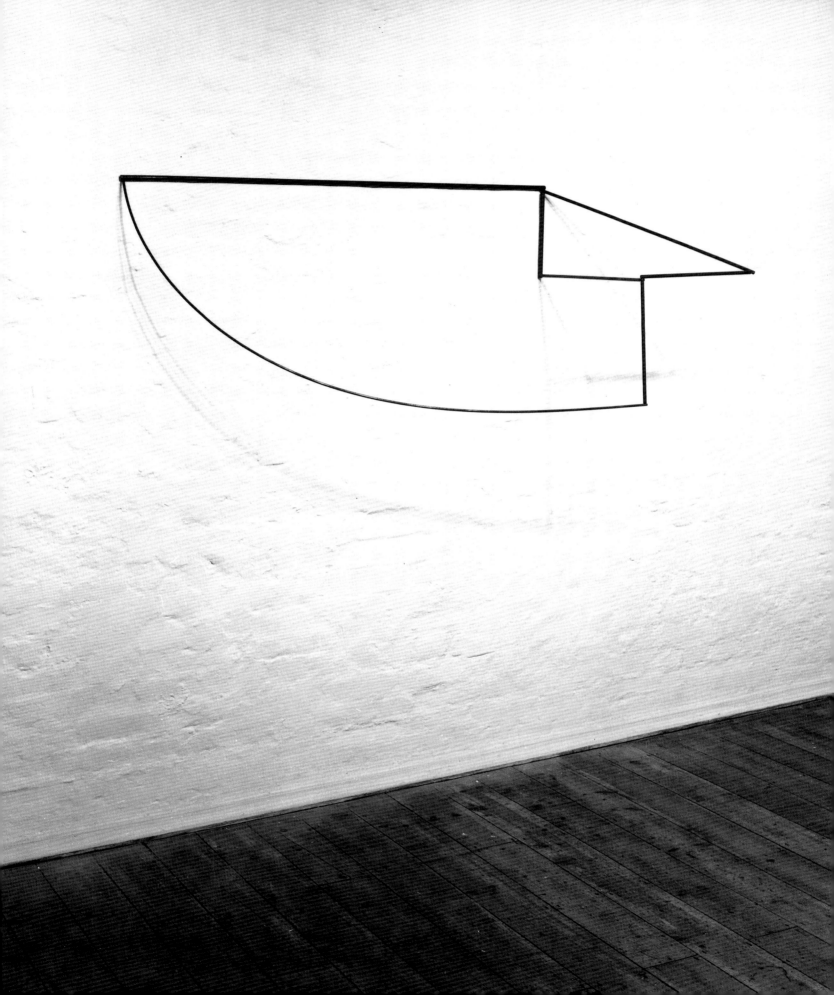

Intrusions/Exclusions, 1980 Painted aluminium 127 x 107 x 19 cm

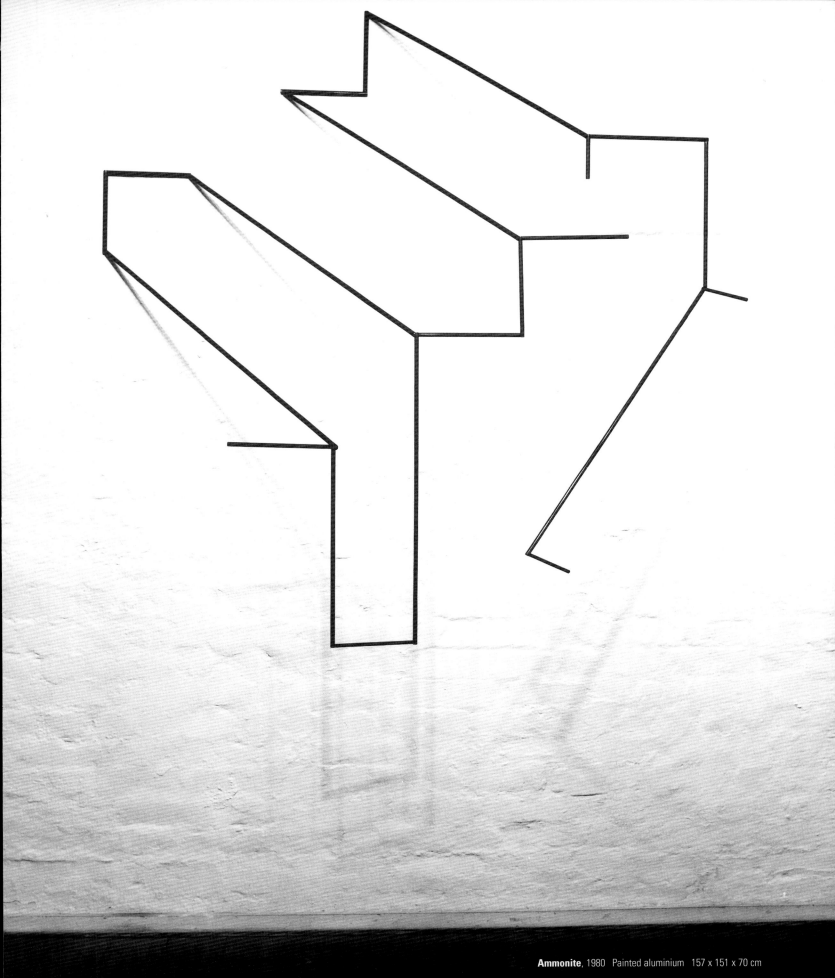

Ammonite, 1980 Painted aluminium 157 x 151 x 70 cm

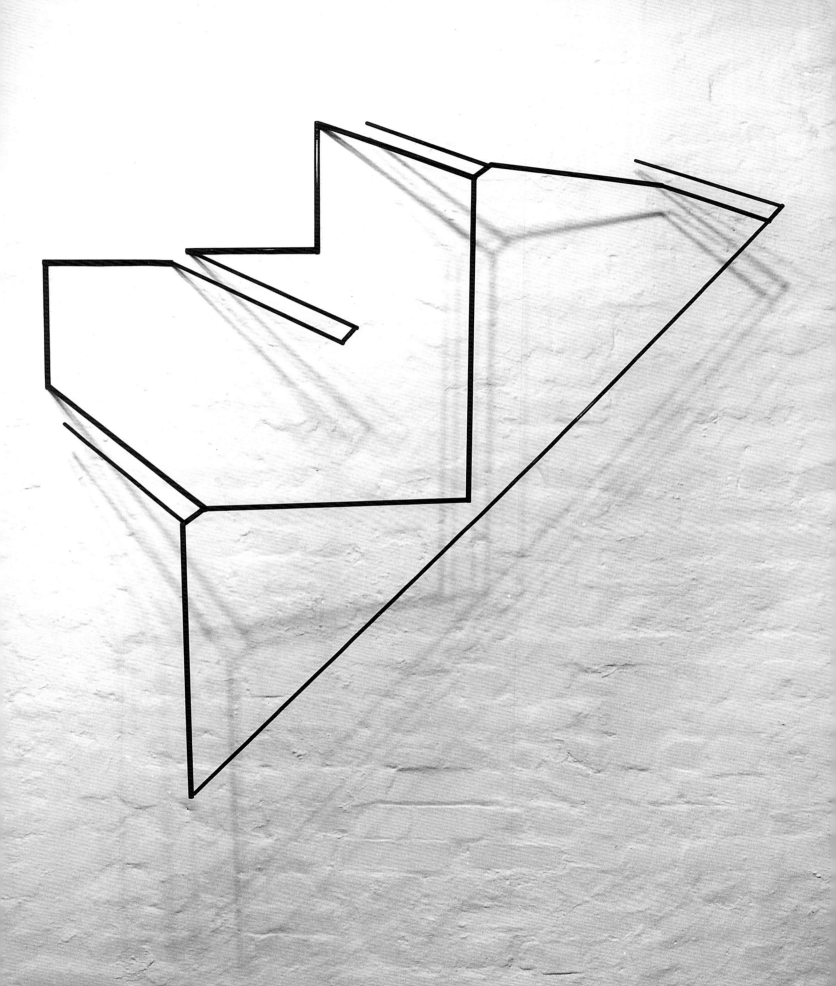

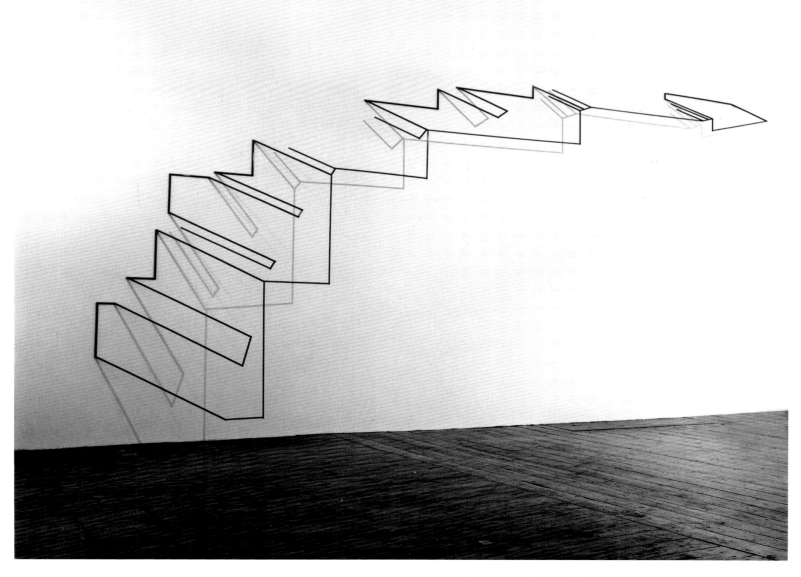

Entrance to an Unnamed Place, 1981 Painted aluminium 289.5 x 616 x 56 cm

Geography of an Unnamed Place, 1981 Painted aluminium 101 x 96 x 61 cm

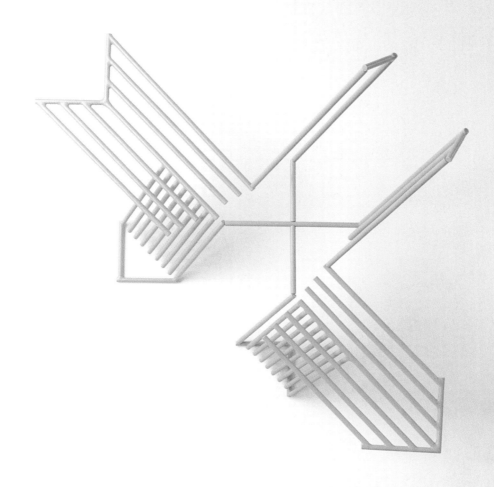

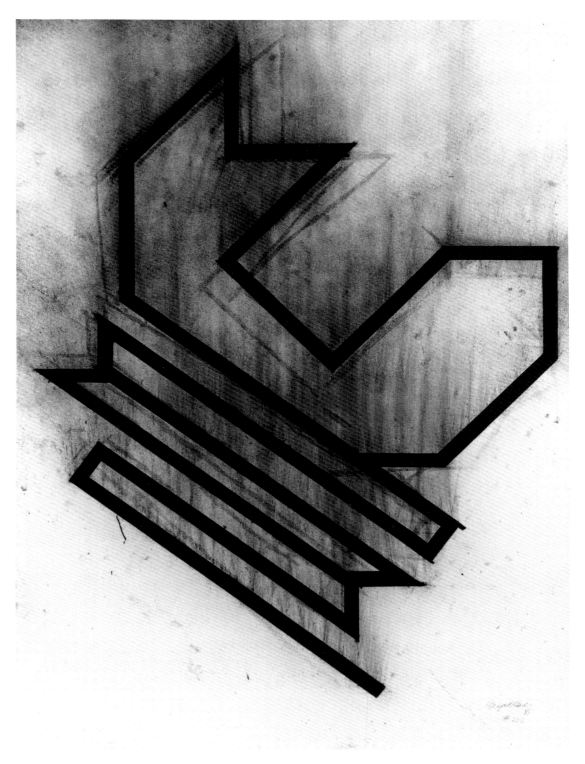

Drawing 199, 1981 Charcoal on paper 137.2 x 101.7 cm

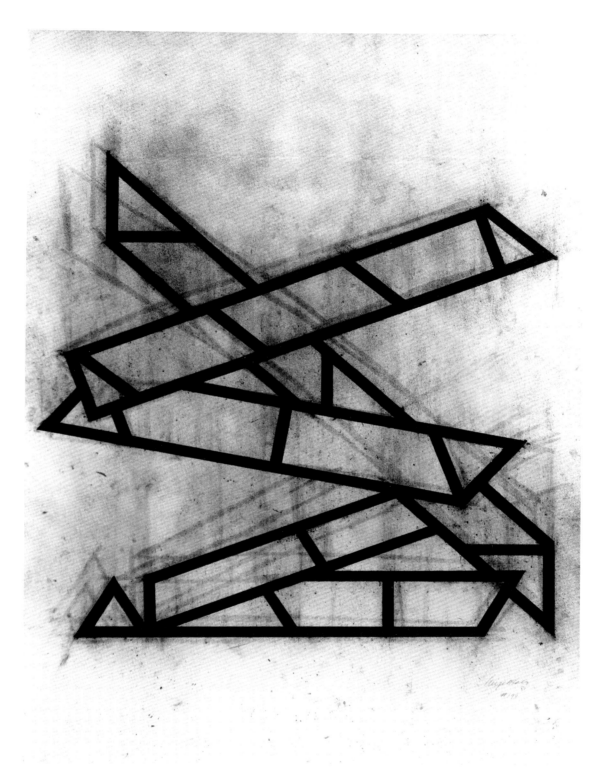

Drawing 222, 1981 Charcoal on paper 137.2 x 101.7 cm

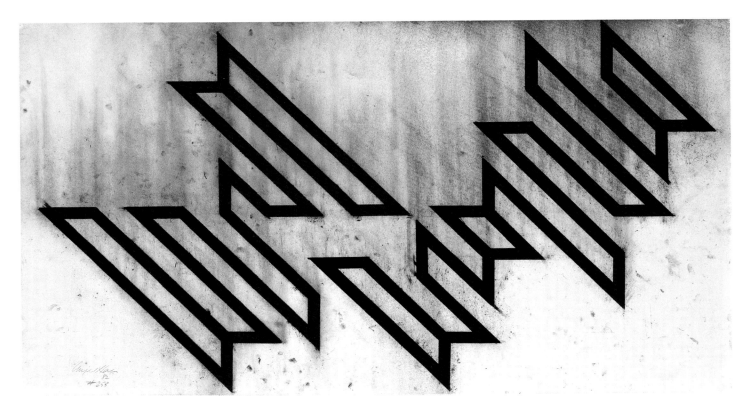

Drawing 253, 1982 Charcoal and pastel on paper 75.6 x 137.3 cm

Black Shoal, 1982 Painted aluminium 231 x 96 x 32.5 cm

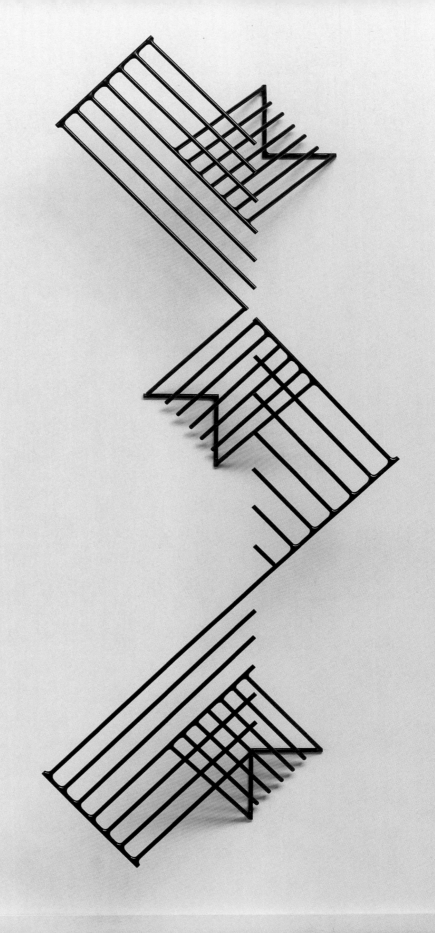

Study for Australian National Gallery (First Version), 1982 Painted aluminium 266.5 x 591.5 x 56 cm

92

Drawing 406, 1985 Charcoal and pastel on paper 133 x 165 cm

Cedar of Lebanon, 1984 Painted aluminium 248 x 235 x 97.8 cm

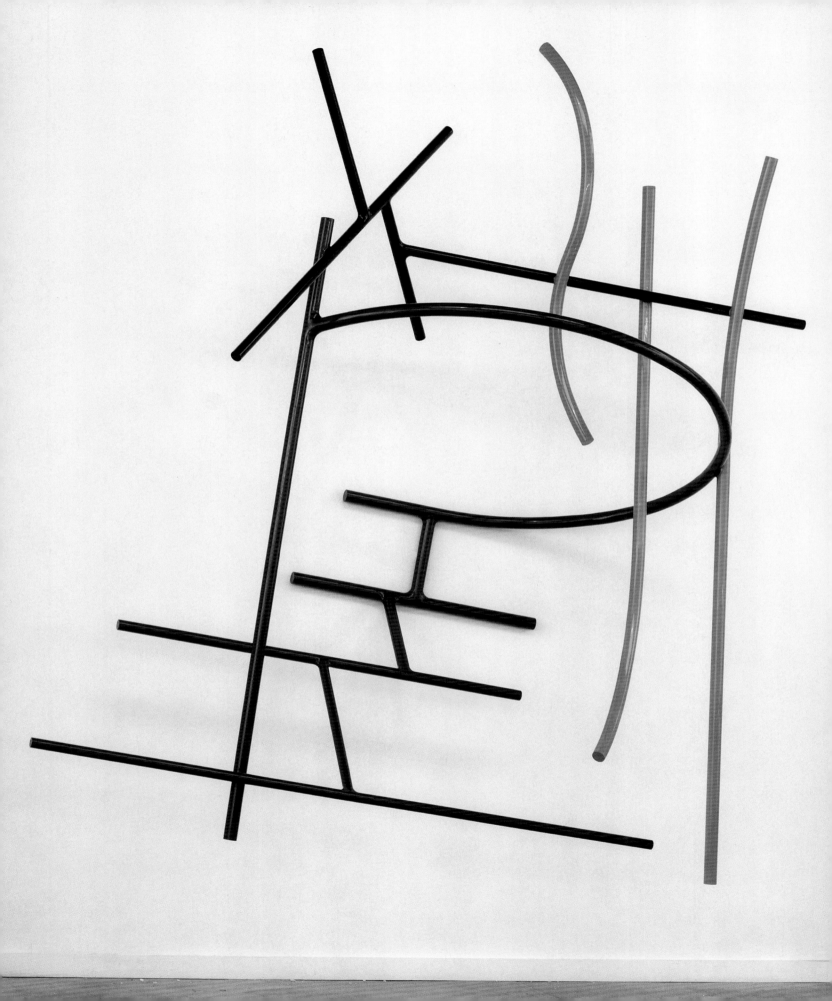

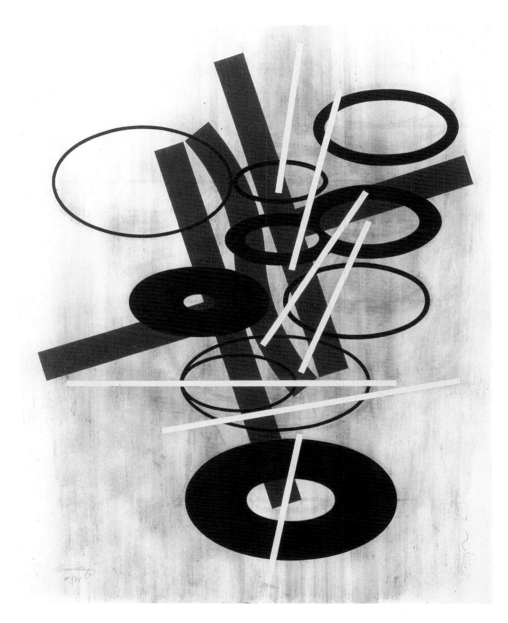

Drawing 586, 1987 Gouache and charcoal on paper 152 x 120.5 cm

Gaze Large, 1988 Cast bronze (unique) 243 x 134 x 177 cm

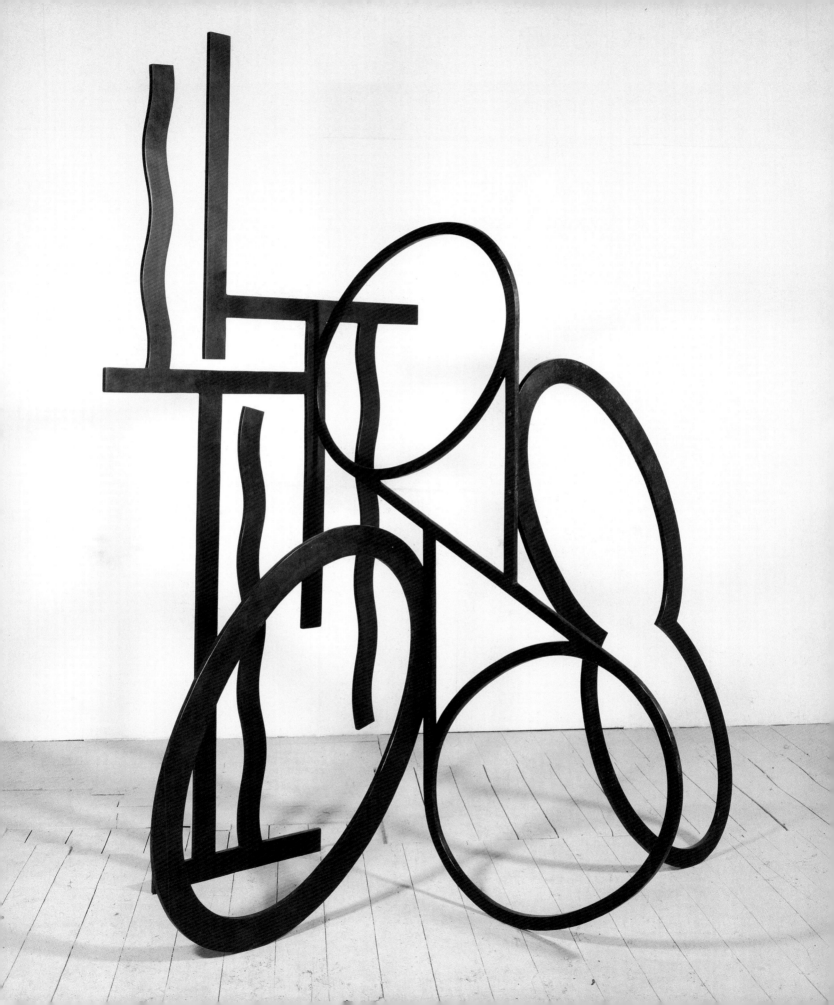

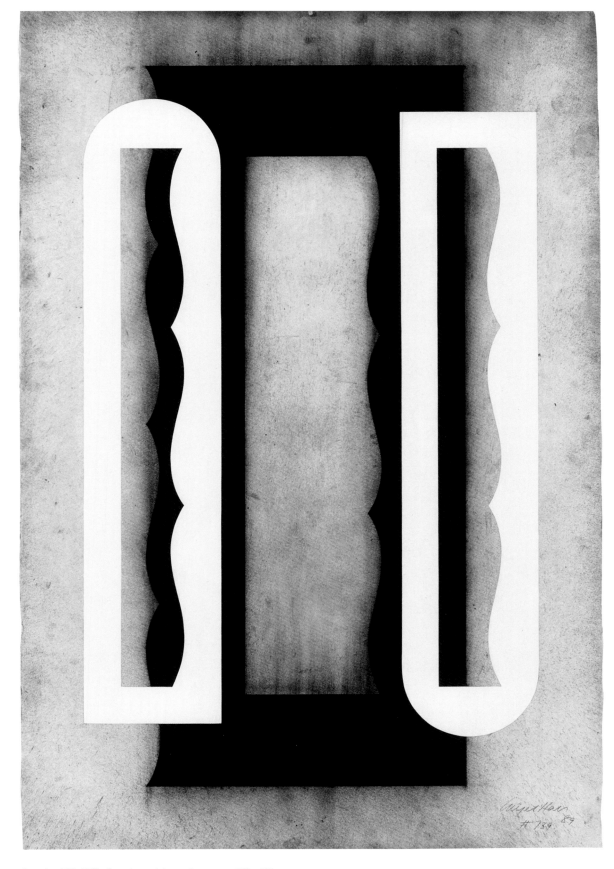

Drawing 739, 1989 Gouache and charcoal on paper 153 x 102 cm

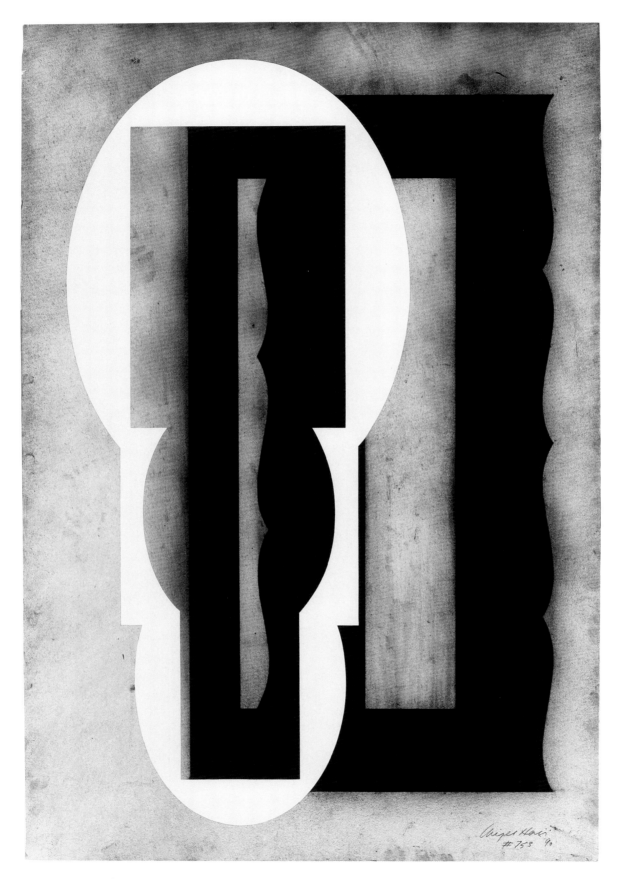

Drawing 753, 1990 Gouache and charcoal on paper 153 x 102 cm

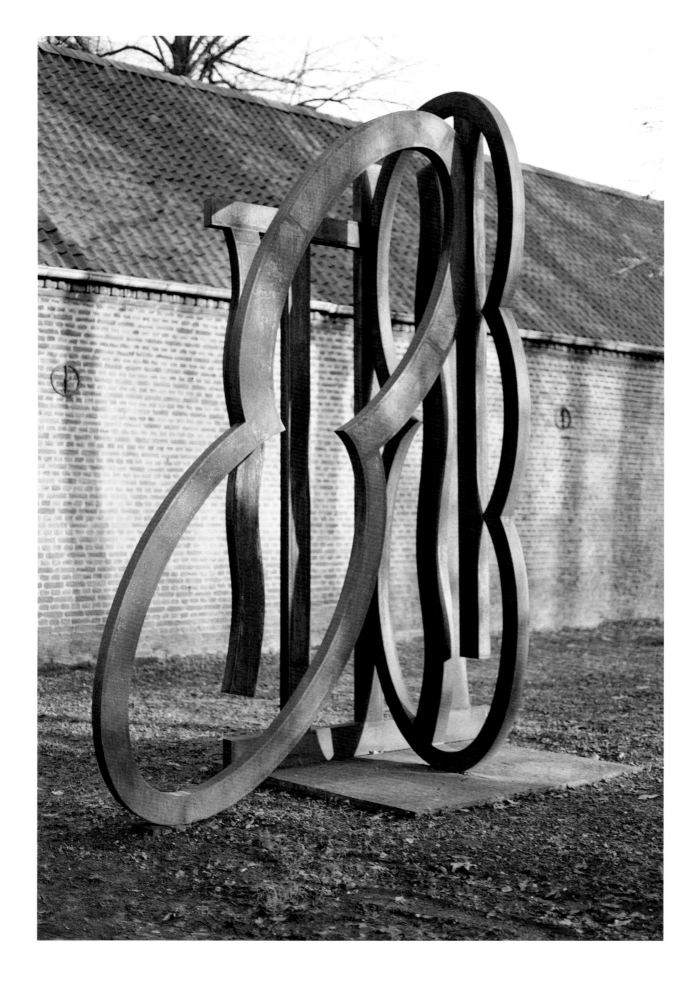

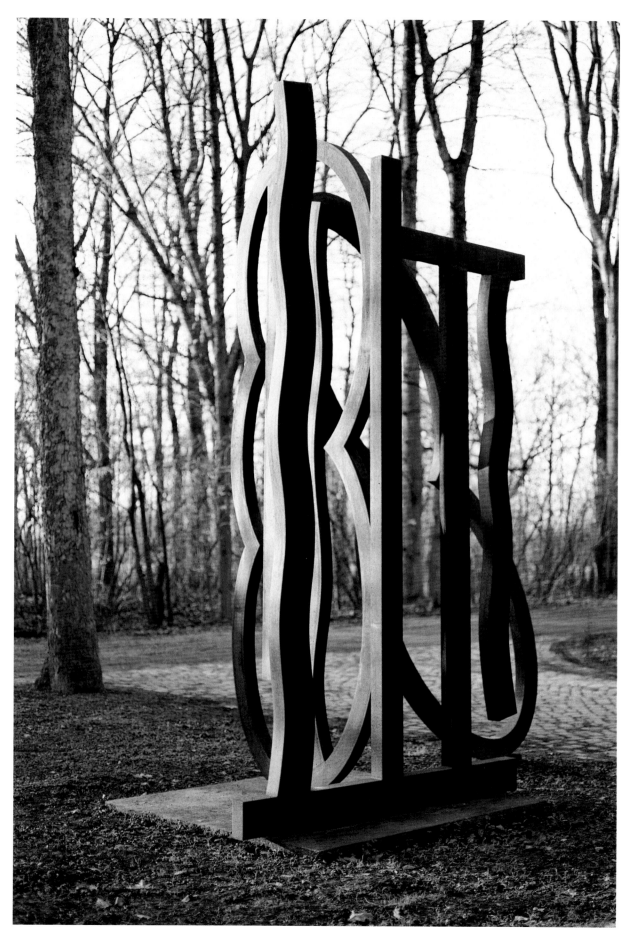

Introspective Sentry, 1992 (two views) Corten steel 450 x 366 x 153 cm

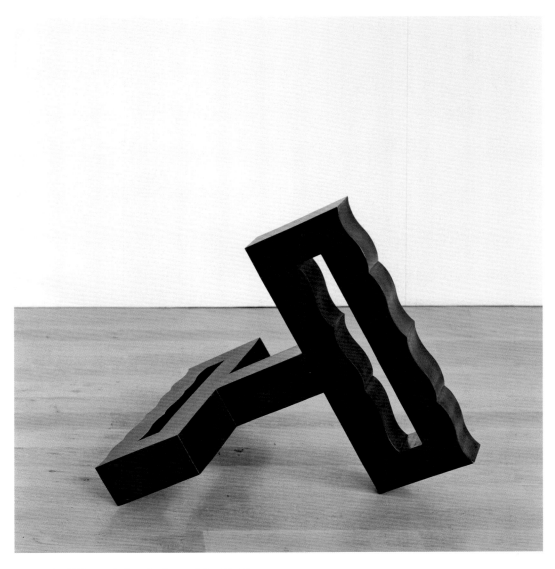

Narrow Fex Valley, 1990 Phosphor bronze 74.5 x 86 x 72 cm

Glacier, 1991 Phosphor bronze 223 x 179 x 79 cm

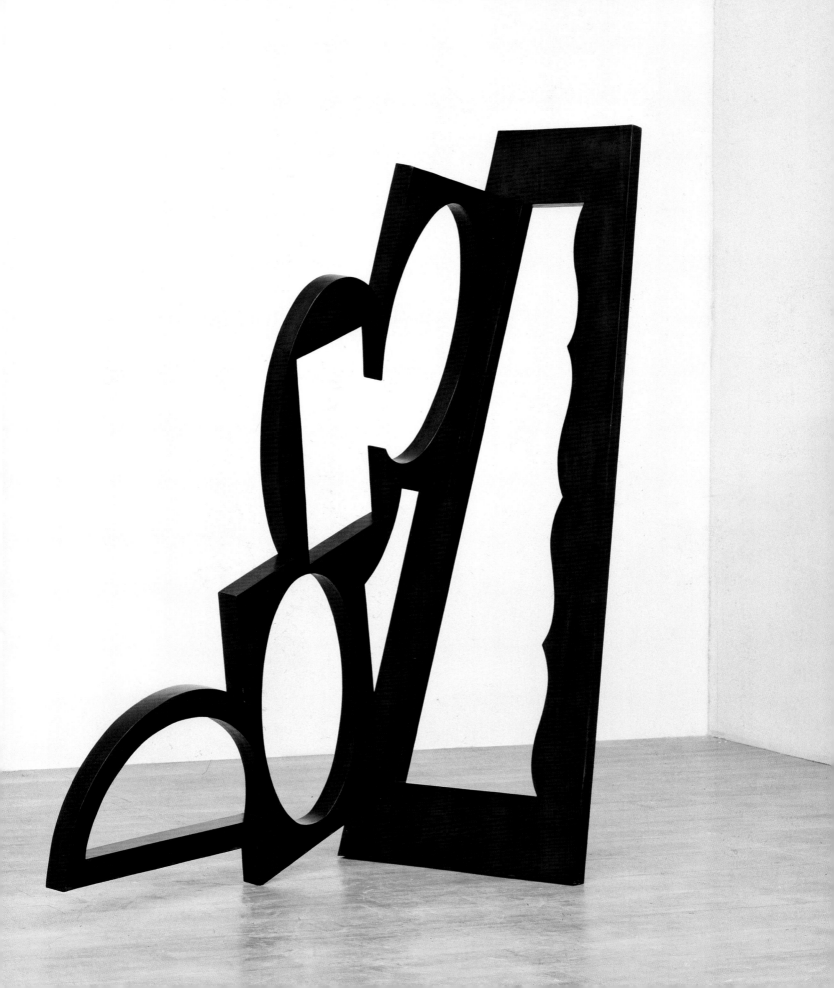

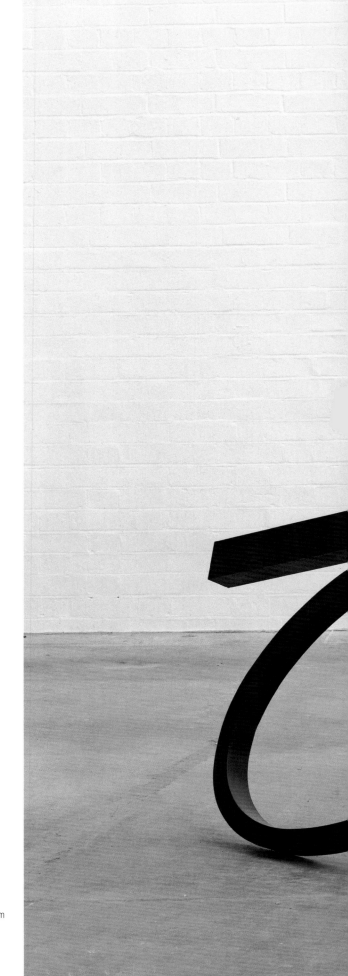

Acorn, 1990 Corten steel 173.5 x 291 x 247.5 cm

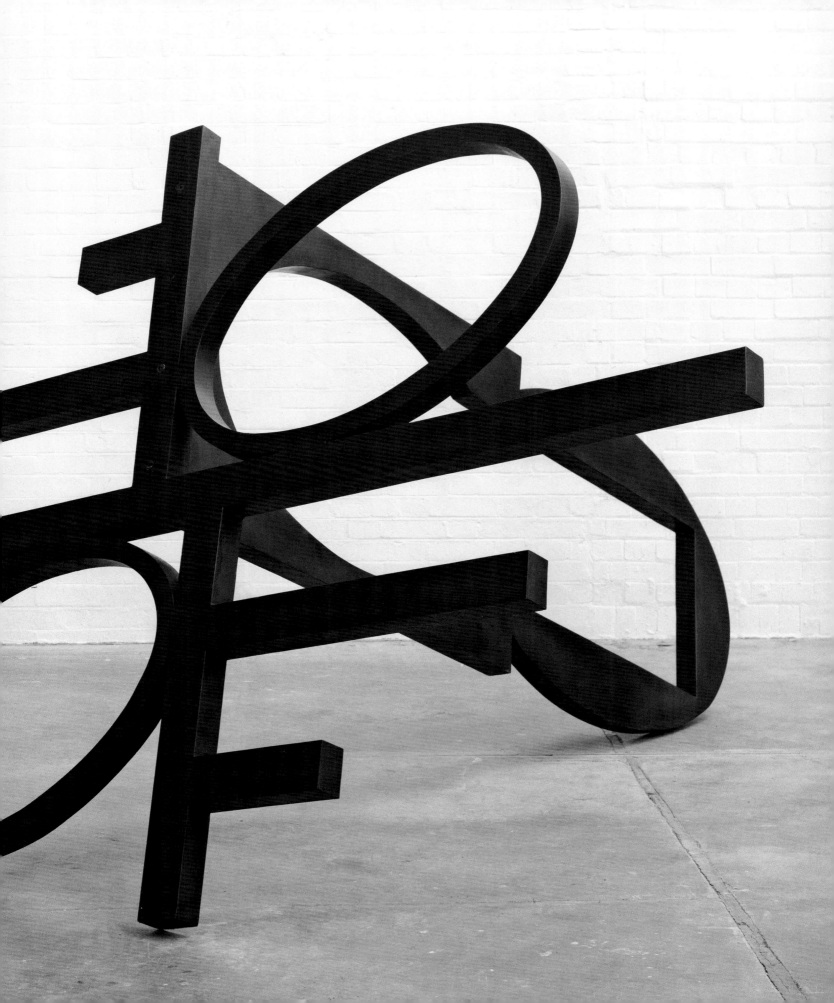

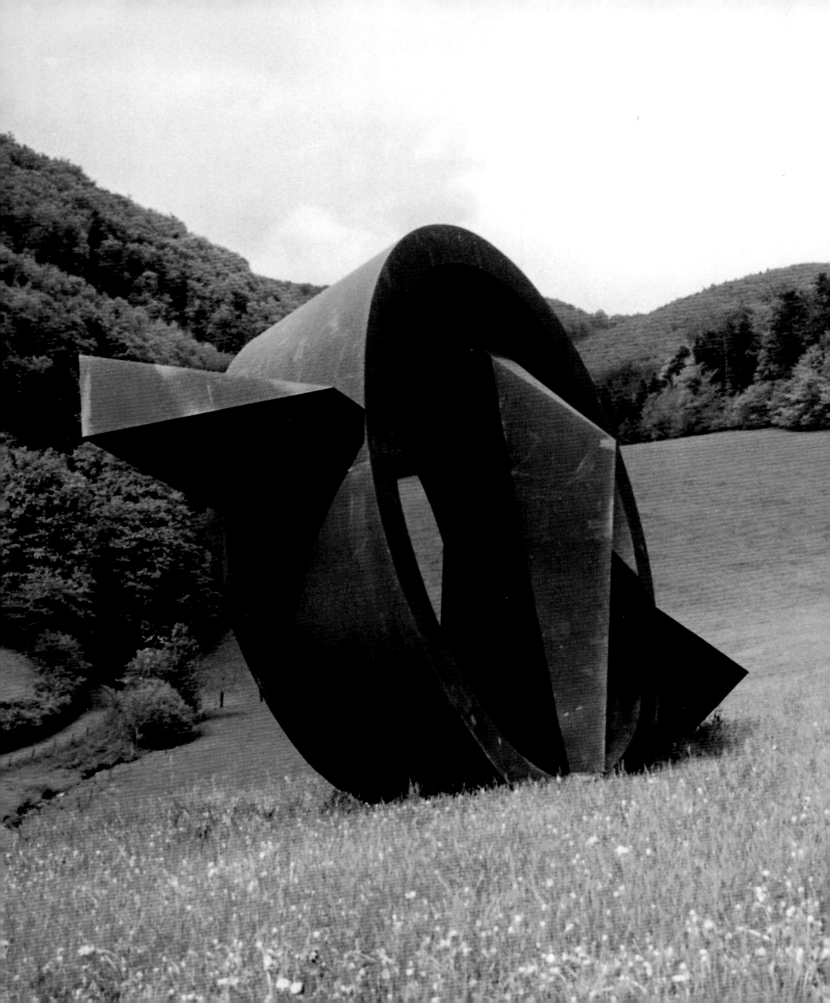

Soglio (Schoenthal), 1994 Corten steel 550 x 1100 x 308 cm

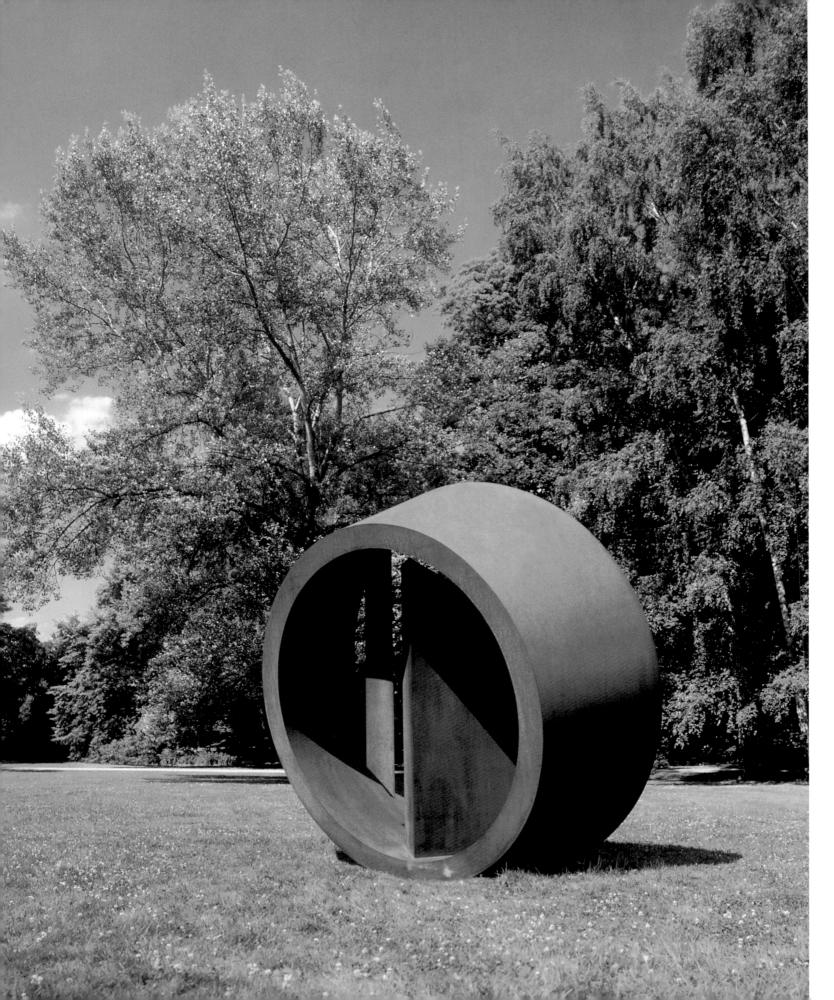

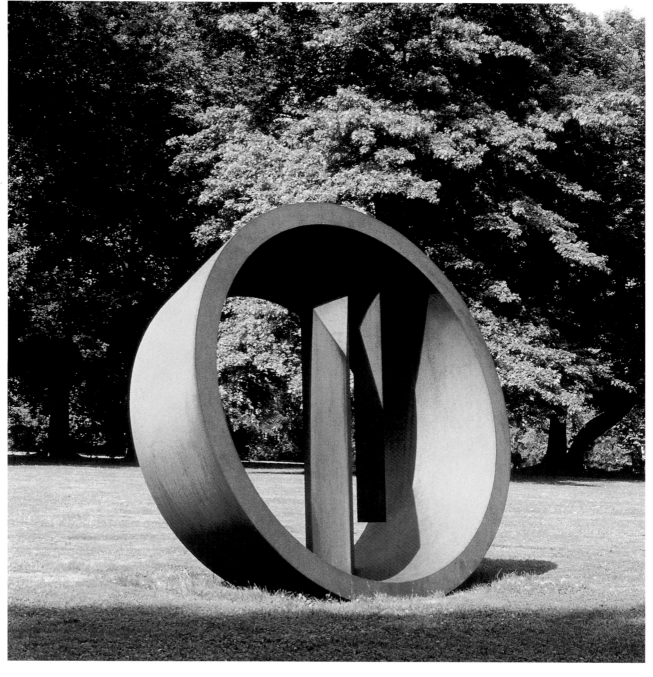

Within and Without II, 1999 (two views) Corten steel 244.6 x 250 x 135 cm

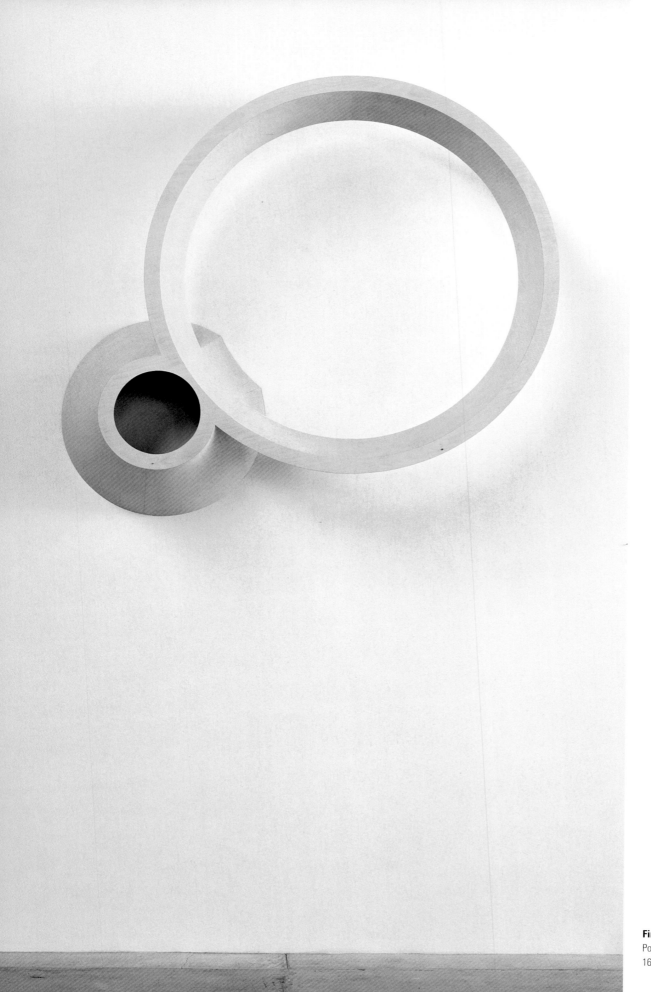

Finally Beginning, 1998
Polished wood
165.5 x 184 x 36.5 cm

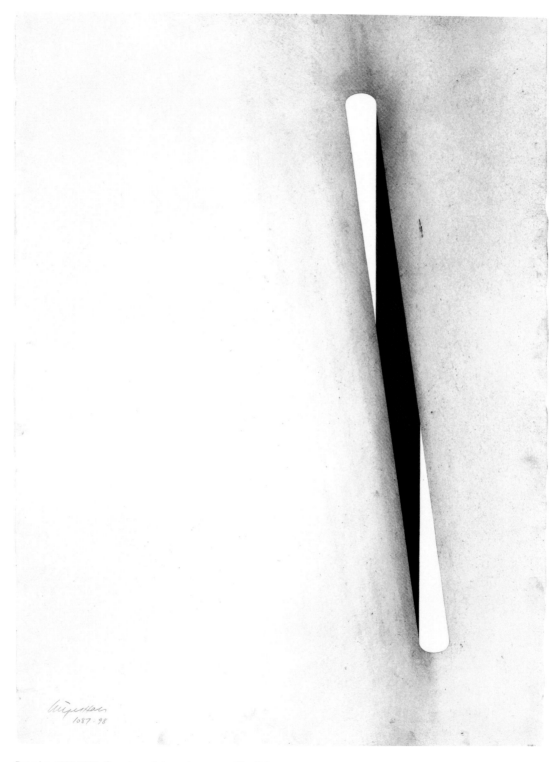

Drawing 1089, 1998 Gouache and charcoal on paper 50 x 46.5 cm

Ship-to-Shore, 1998 Polished wood 208 x 120 x 35 cm

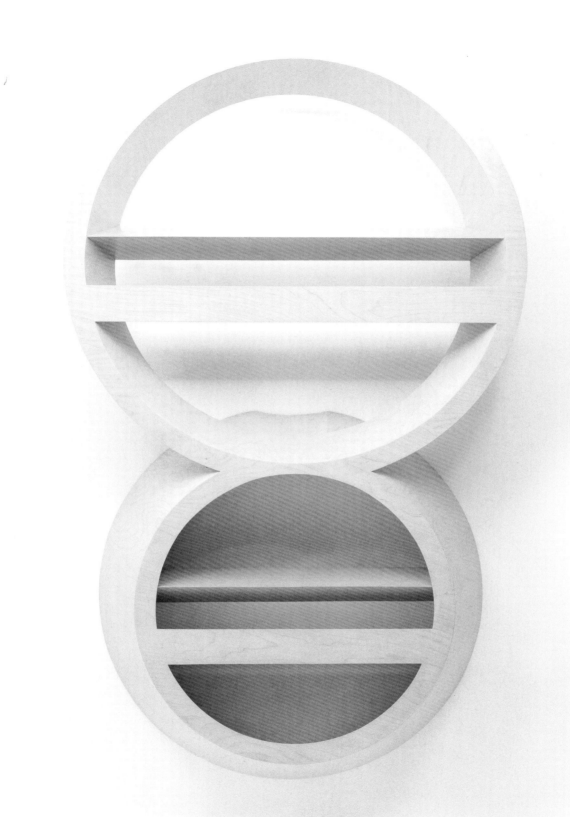

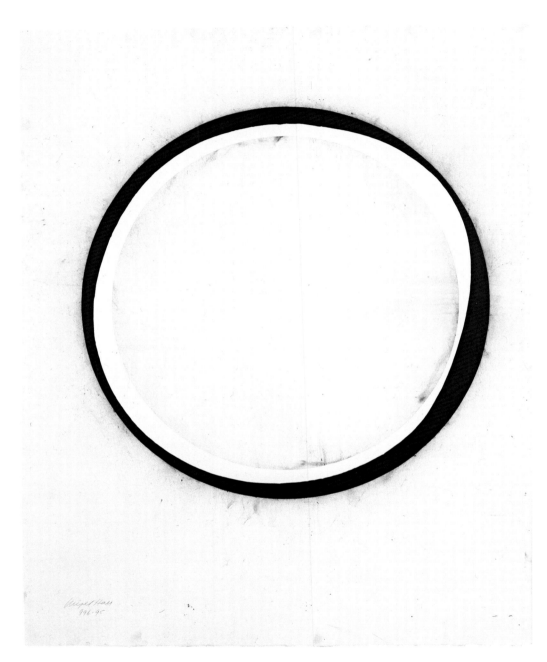

Drawing 996, 1995 Gouache and charcoal on paper 153 x 122 cm

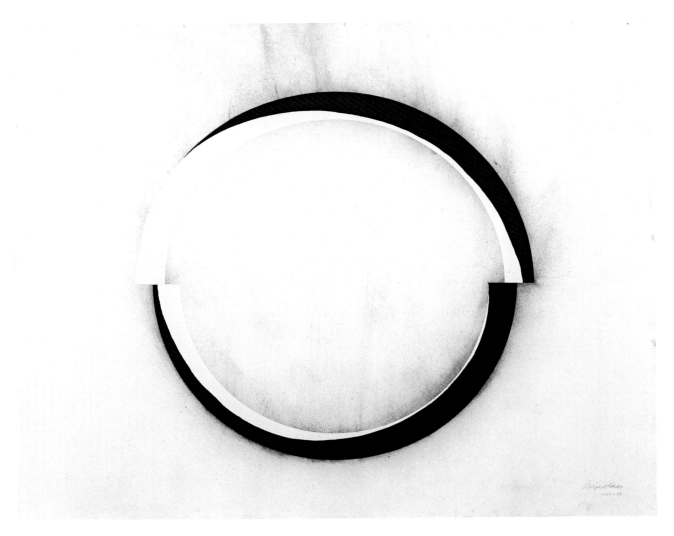

Drawing 1053, 1997 Gouache and charcoal on paper 122 x 153 cm

Spy, 1998 Polished wood 85 x 49.5 x 25 cm

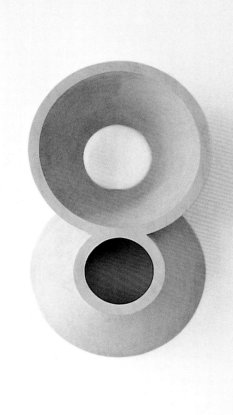

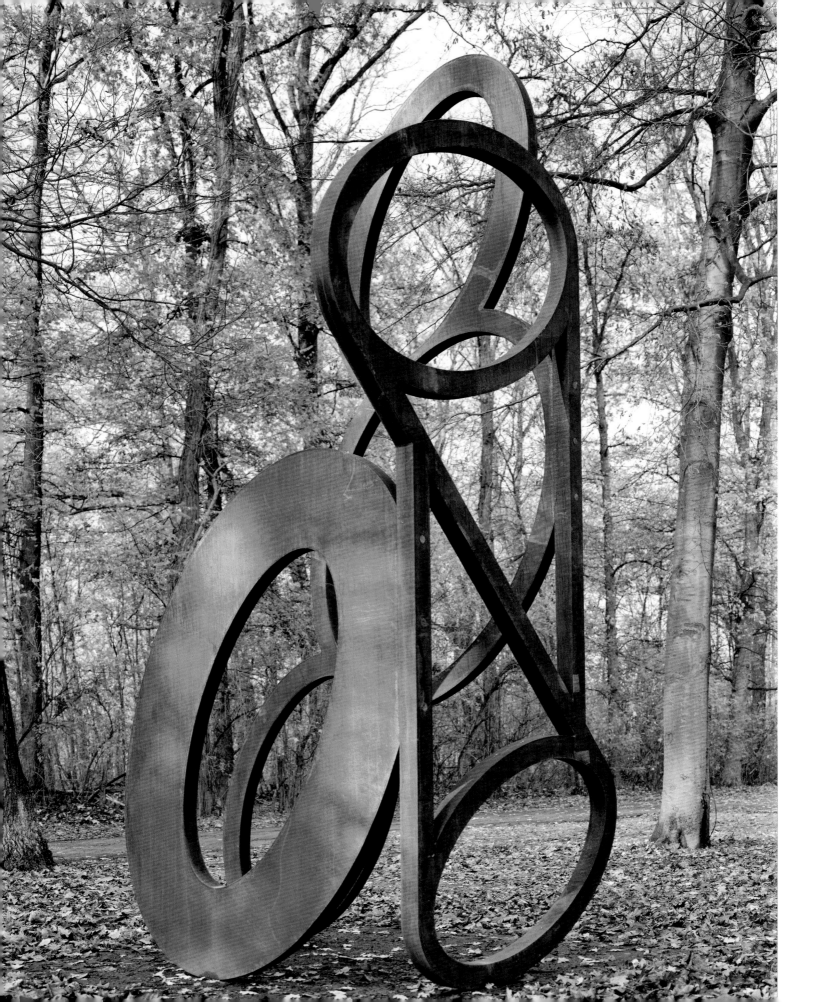

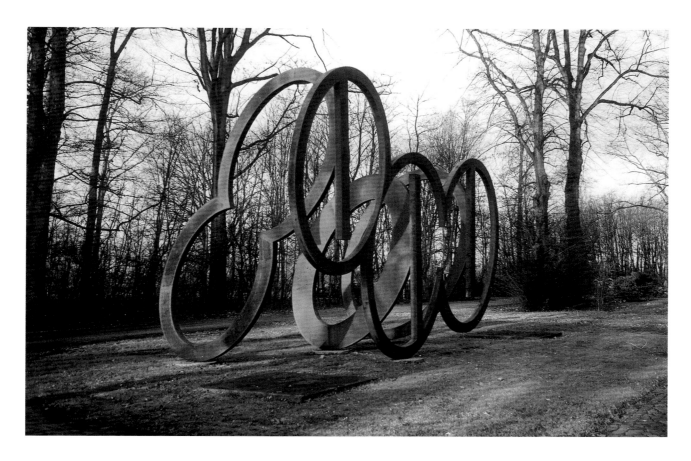

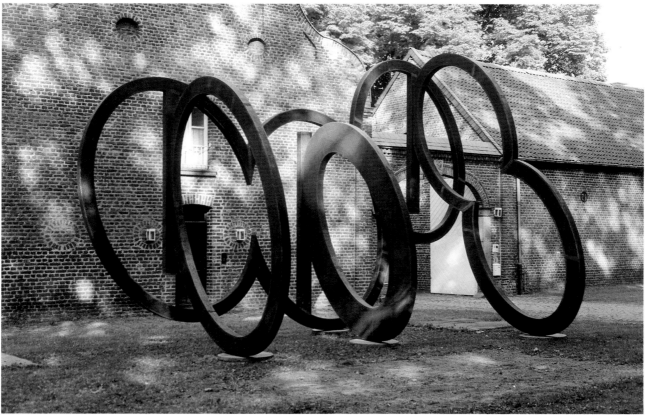

Big River, 1998 (two views) Corten steel 540 x 804 x 408 cm

Arc, 1999 Corten steel 500 x 241 x 229 cm

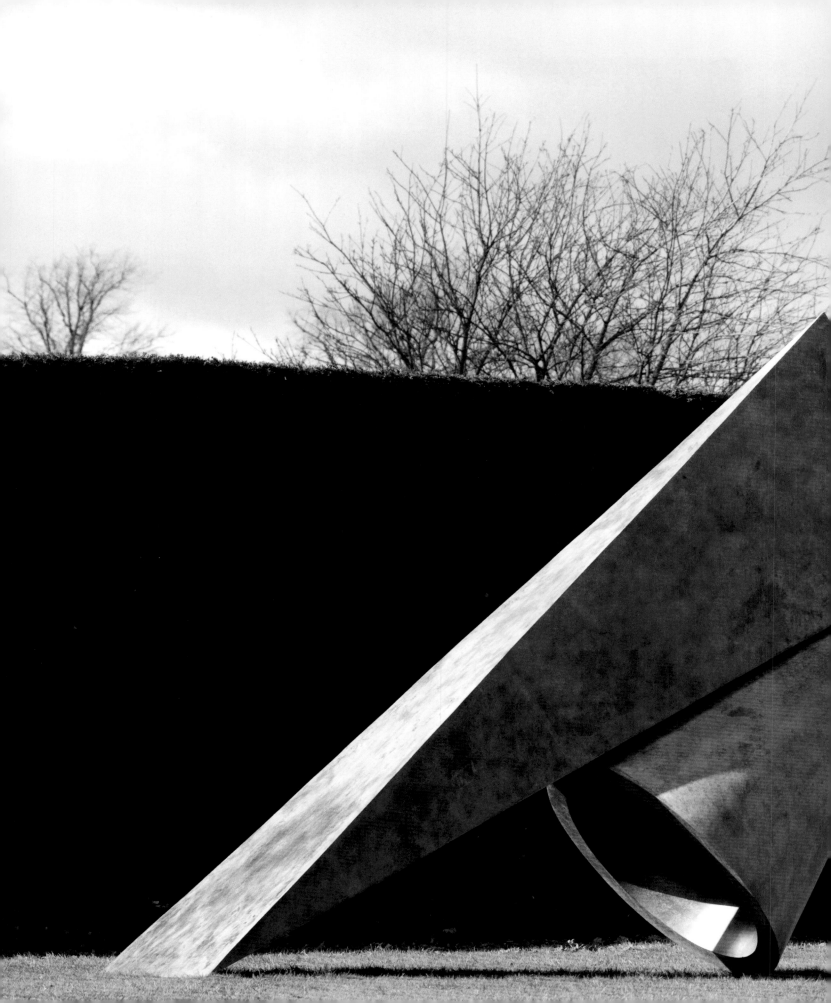

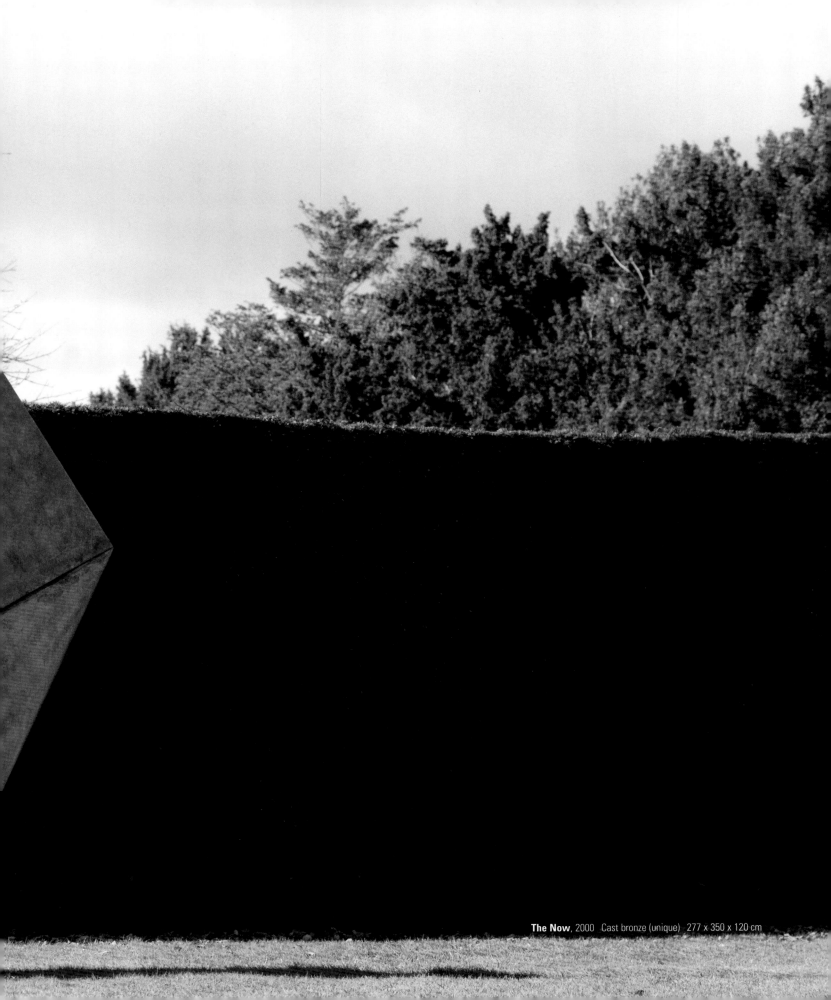

The Now, 2000 Cast bronze (unique) 277 x 350 x 120 cm

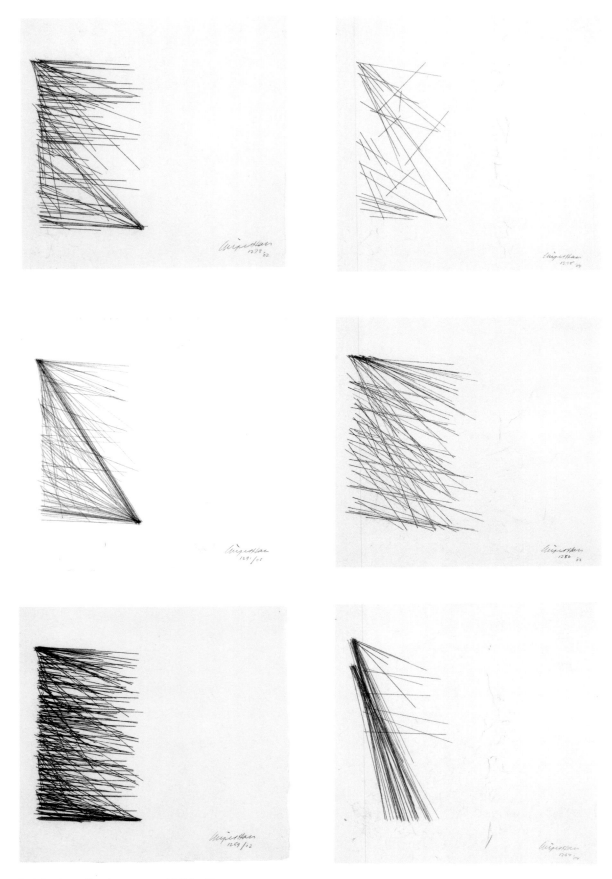

Book drawings All carbon on paper All 23.5 x 24 cm
Clockwise from top left: **Drawing 1273** (from **The Spire** by William Golding), 2002; **Drawing 1295** (from **The Waste Land** by T. S. Eliot), 2004; **Drawing 1280** (from **A Wave** by John Ashbery), 2003; **Drawing 1294** (from **After Nature** by W. G. Sebald), 2004; **Drawing 1259** (from **Underworld** by Don de Lillo), 2002; **Drawing 1291** (from **Heart of Darkness** by Joseph Conrad), 2003

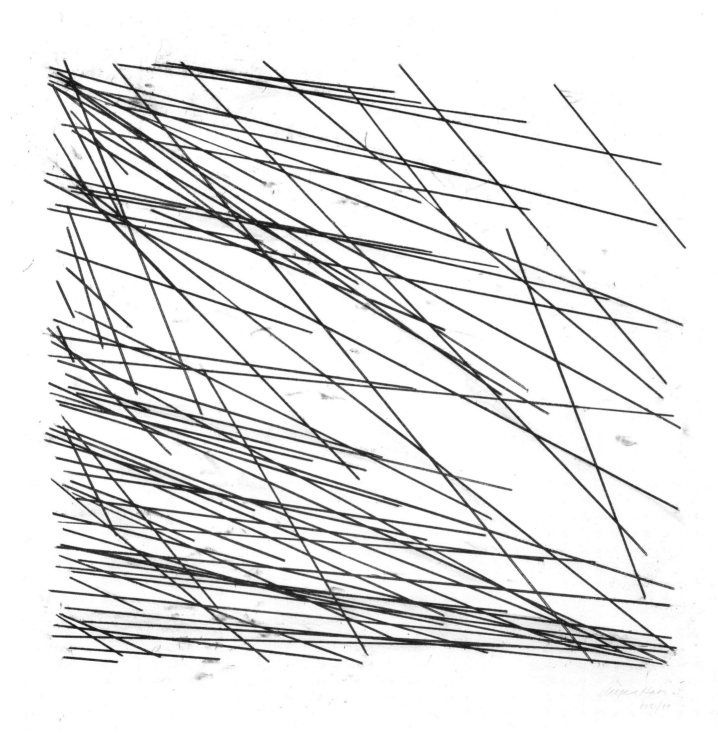

Drawing 1151 (from **The Modular** by Le Corbusier), 1999 Charcoal on paper 126 x 122 cm

Snow Light, 2004 Polished wood 160 x 160 x 29.6 cm

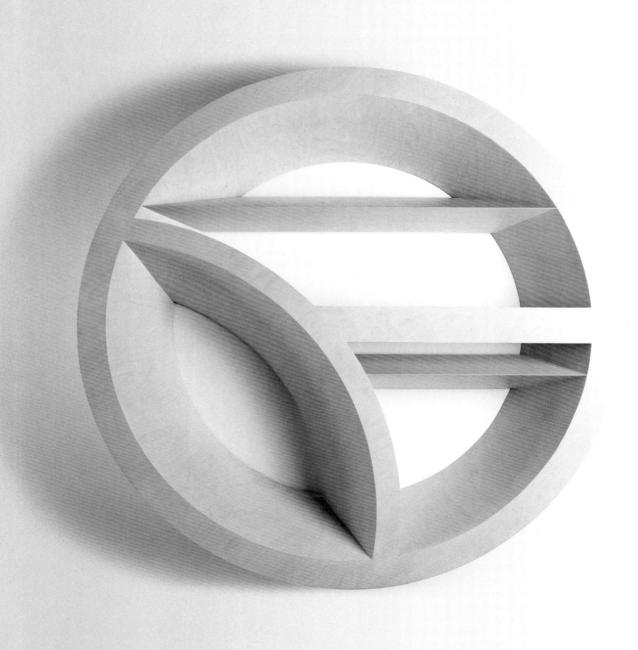

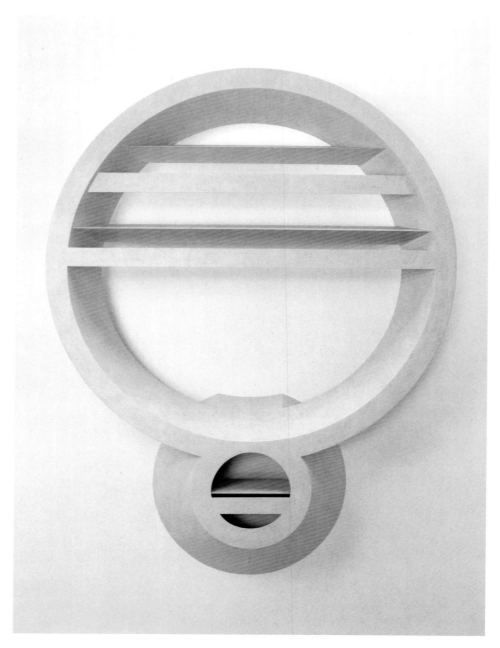

The Hour of Dusk, 2000 Polished wood 222 x 167.4 x 36 cm

Hidden Valley, 1999 Polished wood 146 x 238 x 78 cm

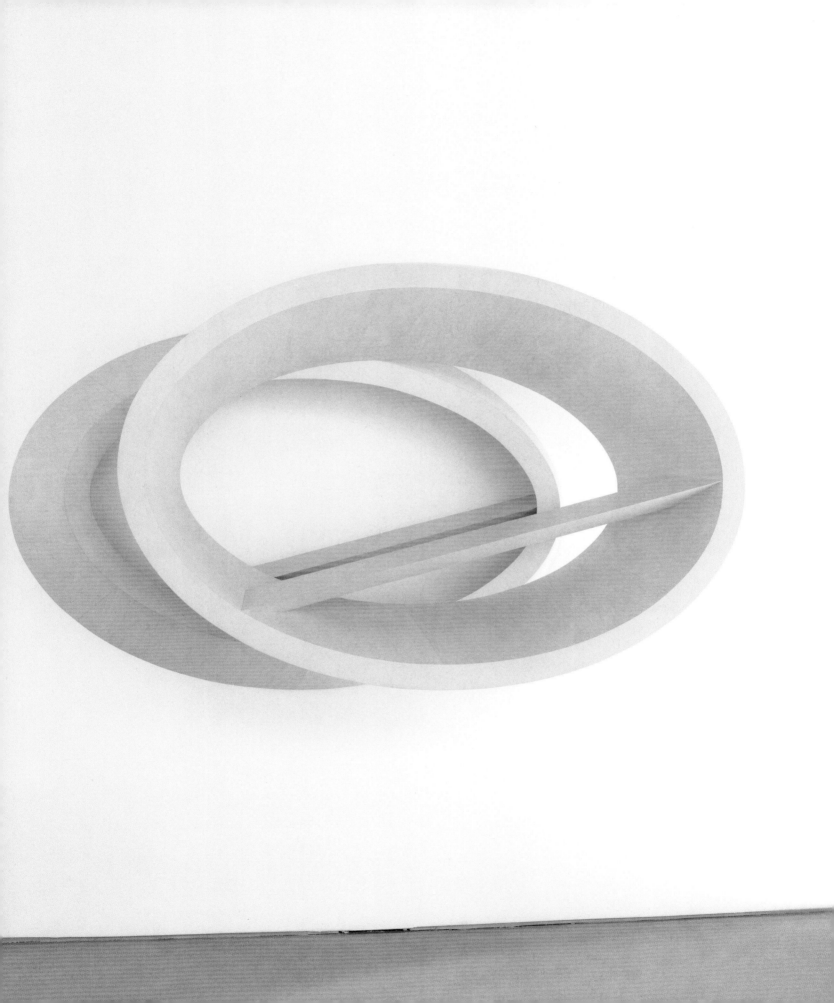

Drawing 1270, 2002 Charcoal on paper 152 x 122 cm

Drawing 1256 (with Korean text), 2002 Charcoal and collage on paper 70 x 100 cm

Winterreise, 2003 Polished wood 122.5 x 122.5 x 22 cm

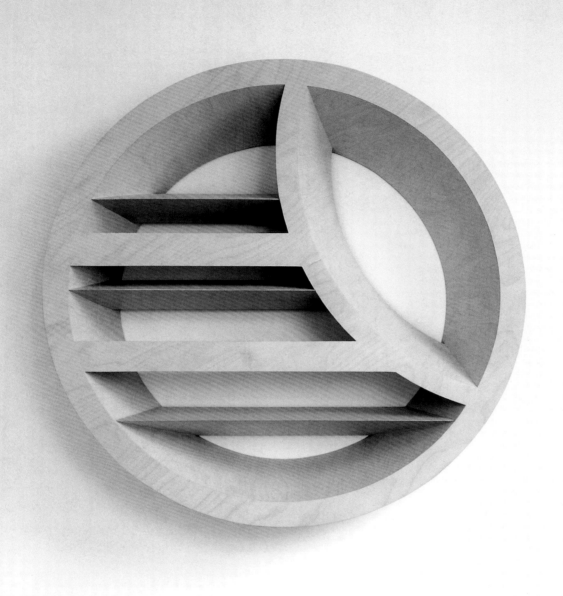

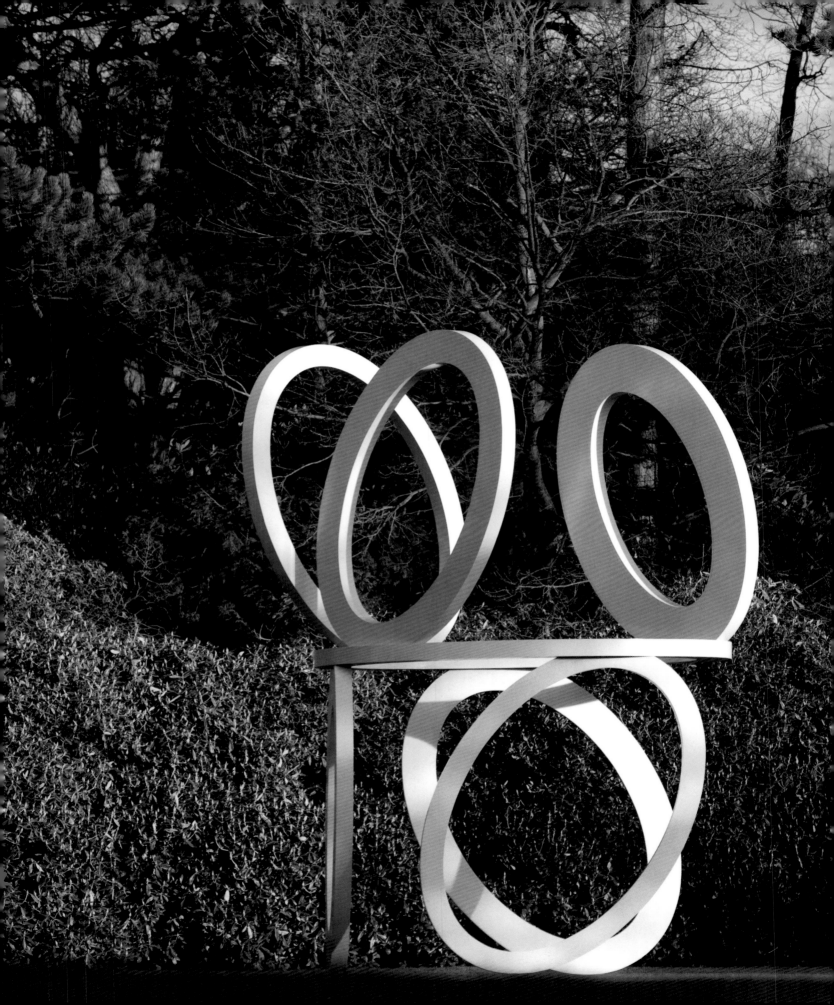

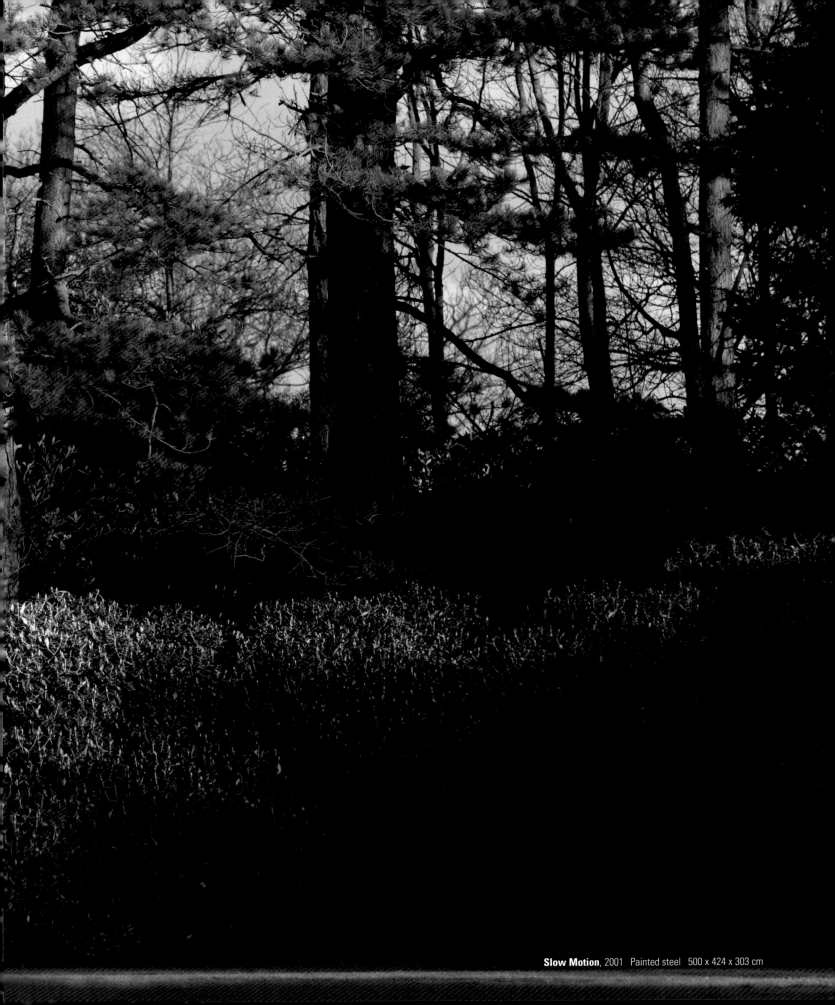

Slow Motion, 2001 Painted steel 500 x 424 x 303 cm

Drifter Diptych, 2004 Polished wood 331.5 x 182.3 x 31 cm

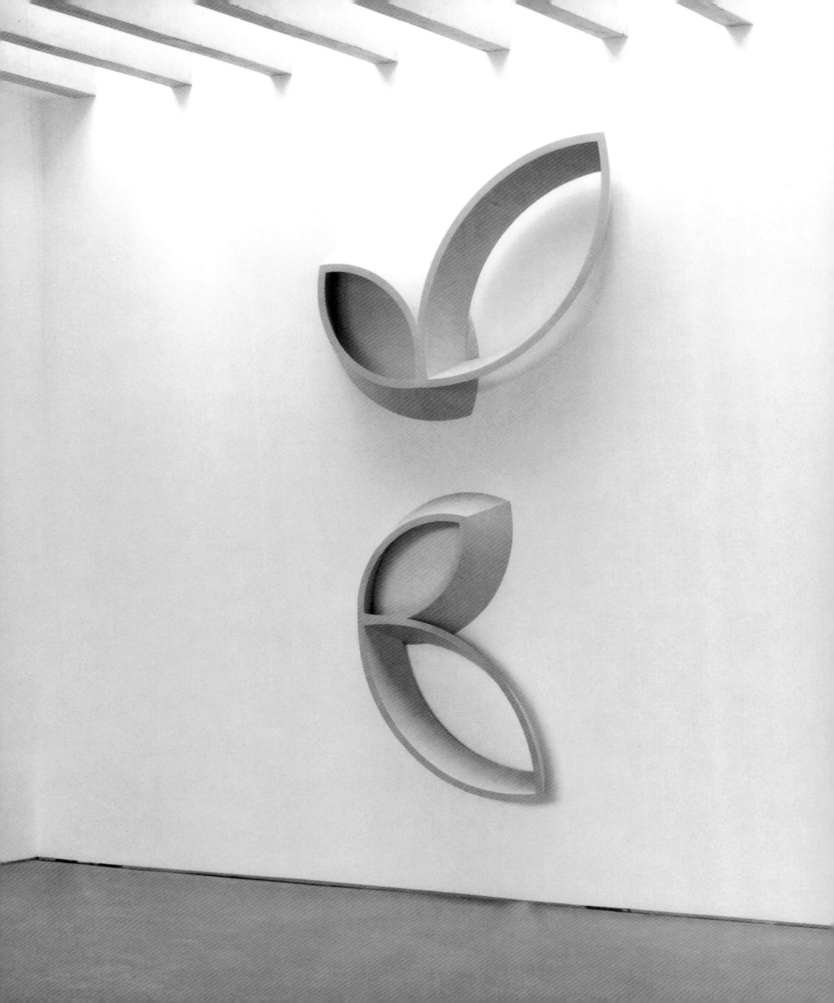

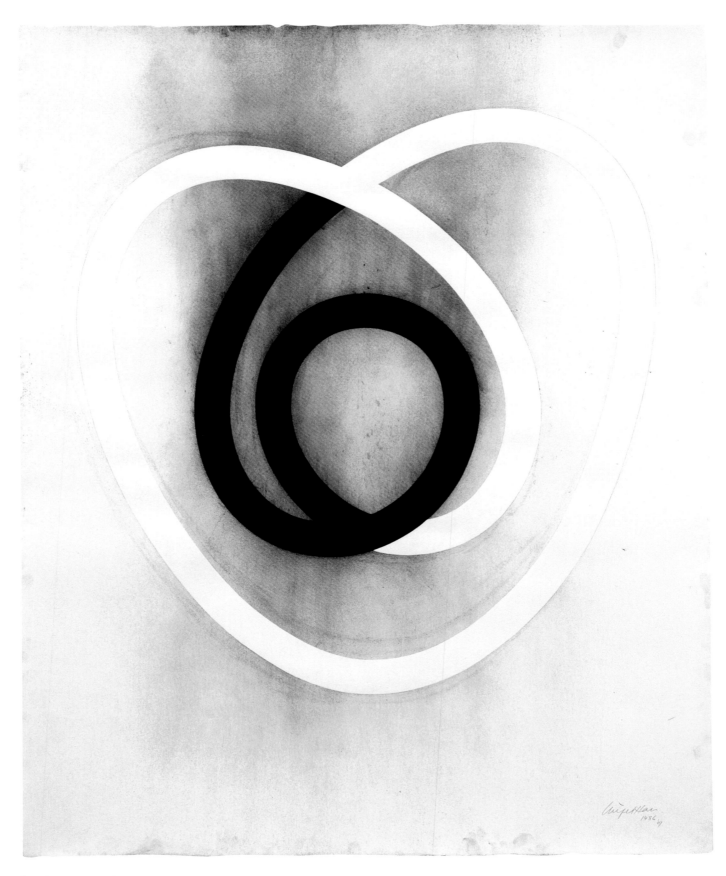

Drawing 1436, 2007 Gouache and charcoal on paper 152 x 122 cm

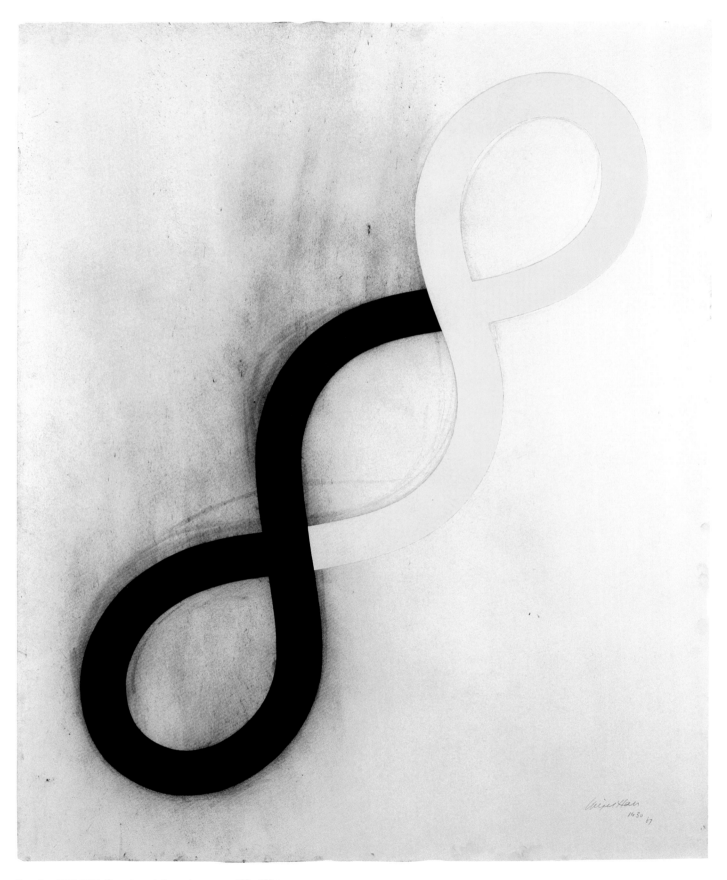

Drawing 1430, 2007 Gouache and charcoal on paper 152 x 122 cm

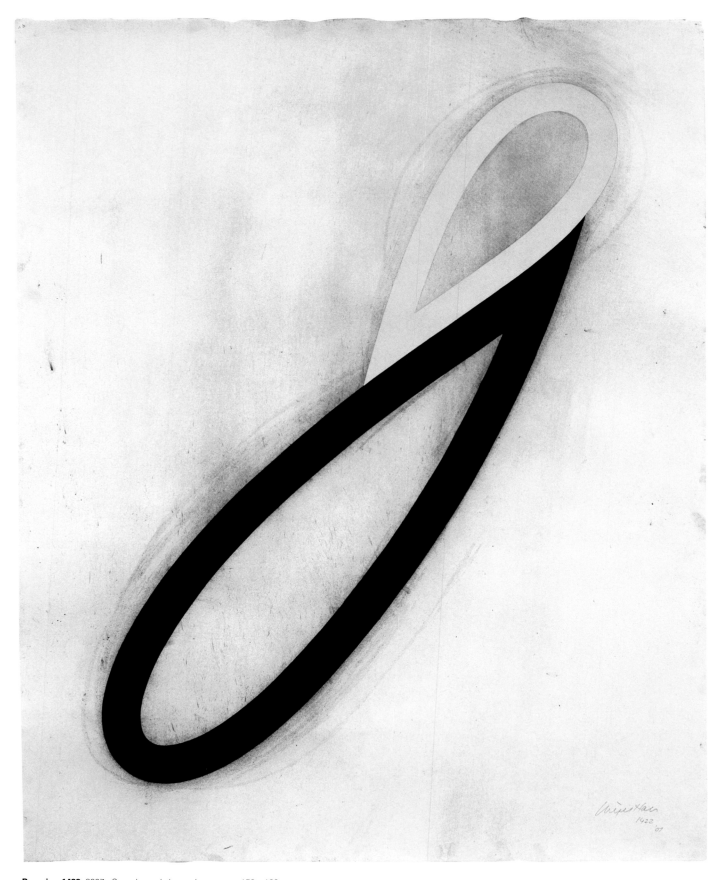

Drawing 1422, 2007 Gouache and charcoal on paper 152 x 122 cm

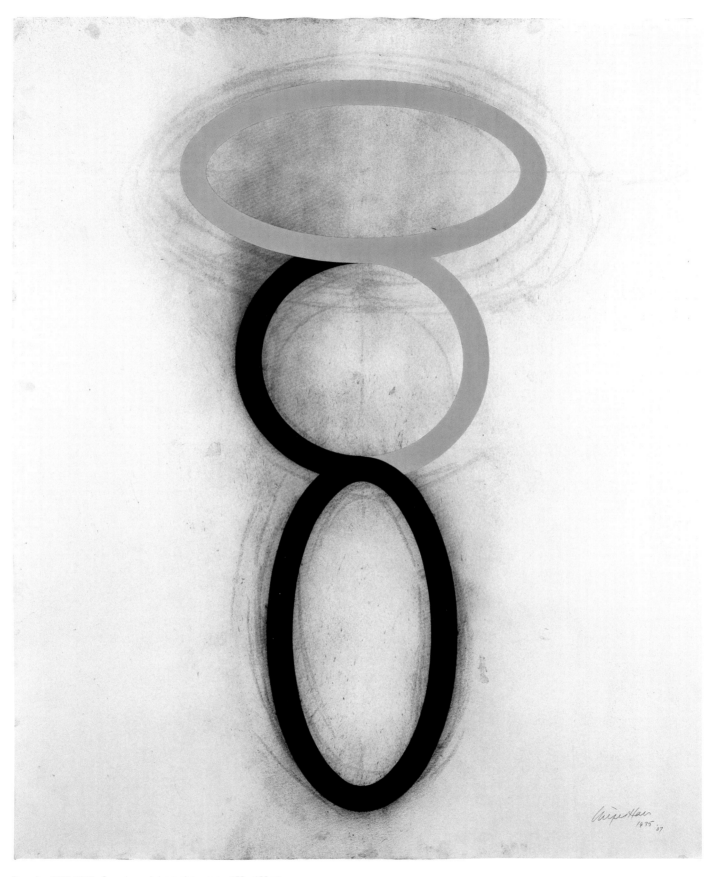

Drawing 1435, 2007 Gouache and charcoal on paper 152 x 122 cm

Drawings 1402, 1403, 1412, 1413, 1415, 1404, 1411, 1405, 1416, 2006 Gouache and charcoal on paper 42 x 29.5 cm (each)

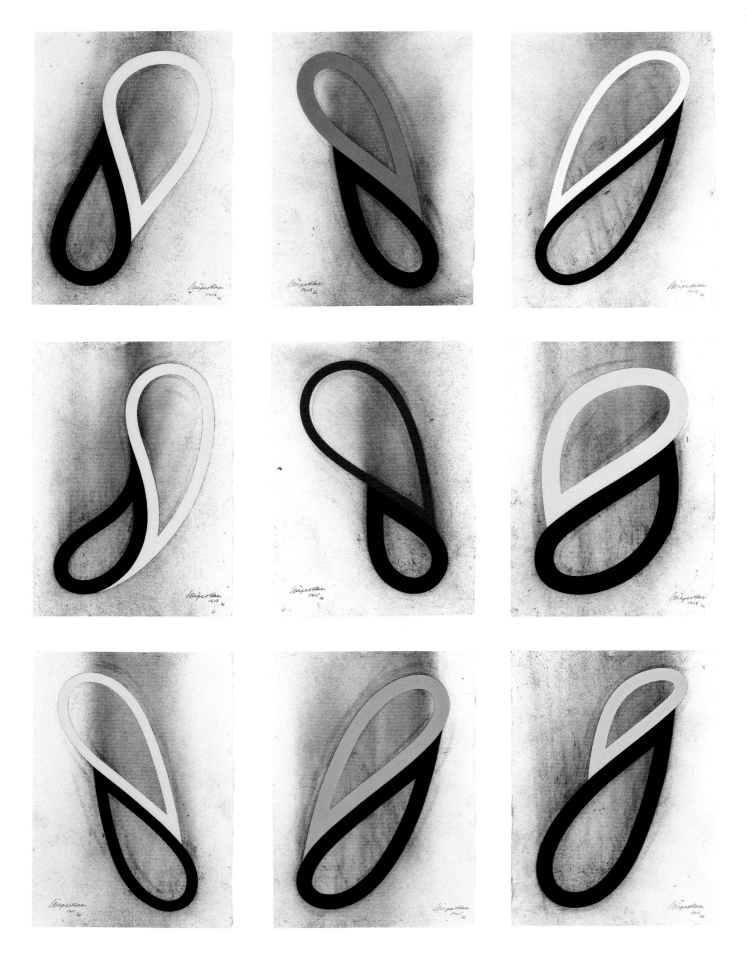

Drawing 1335, 2004 Gouache and charcoal on paper 57.5 x 76.5 cm

Drawing 1333, 2004 Gouache and charcoal on paper 57.5 x 76.5 cm

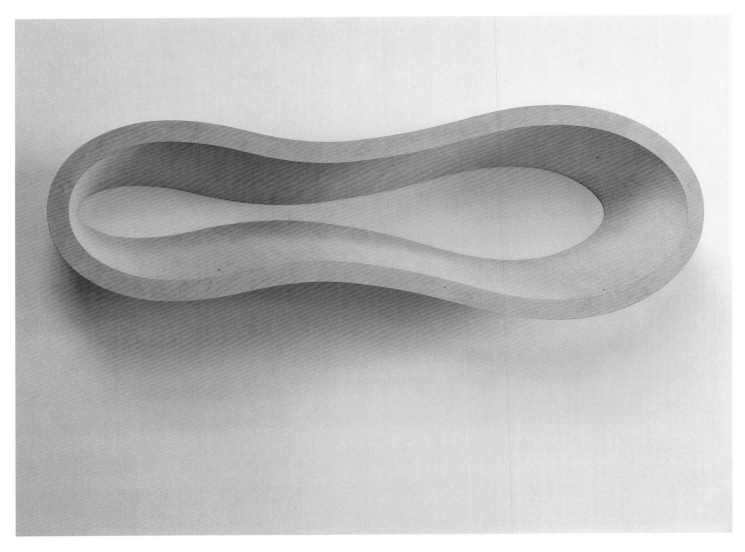

In the Bergell (Stampa), 2006 Polished wood 95 x 300.6 x 41 cm

In the Bergell (Soglio), Large, 2006 Polished wood 266 x 46.2 x 19 cm

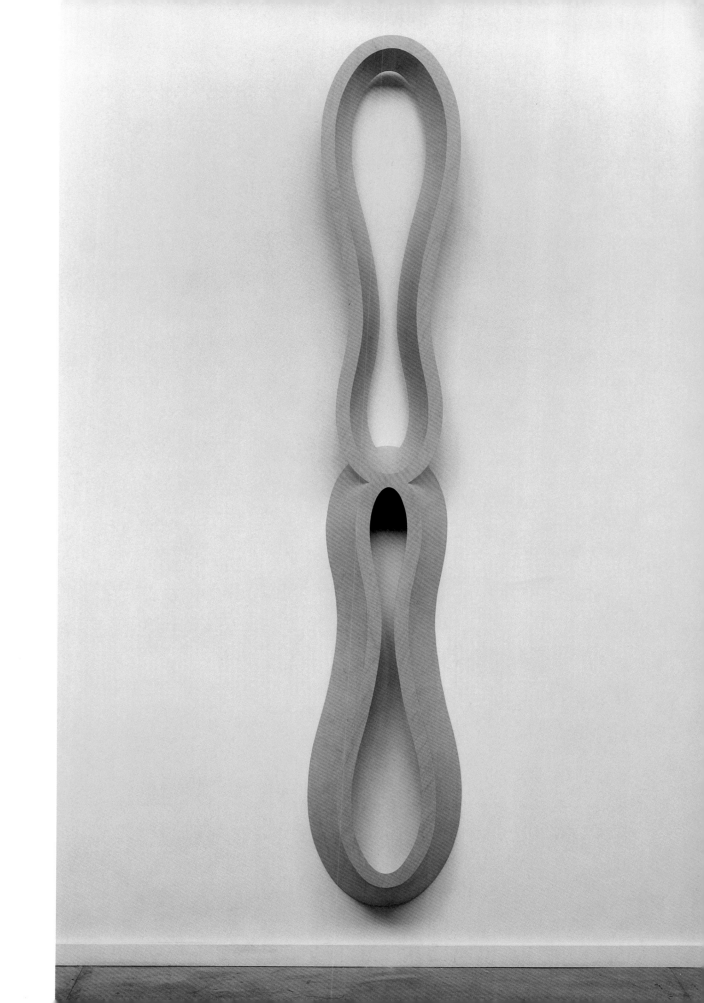

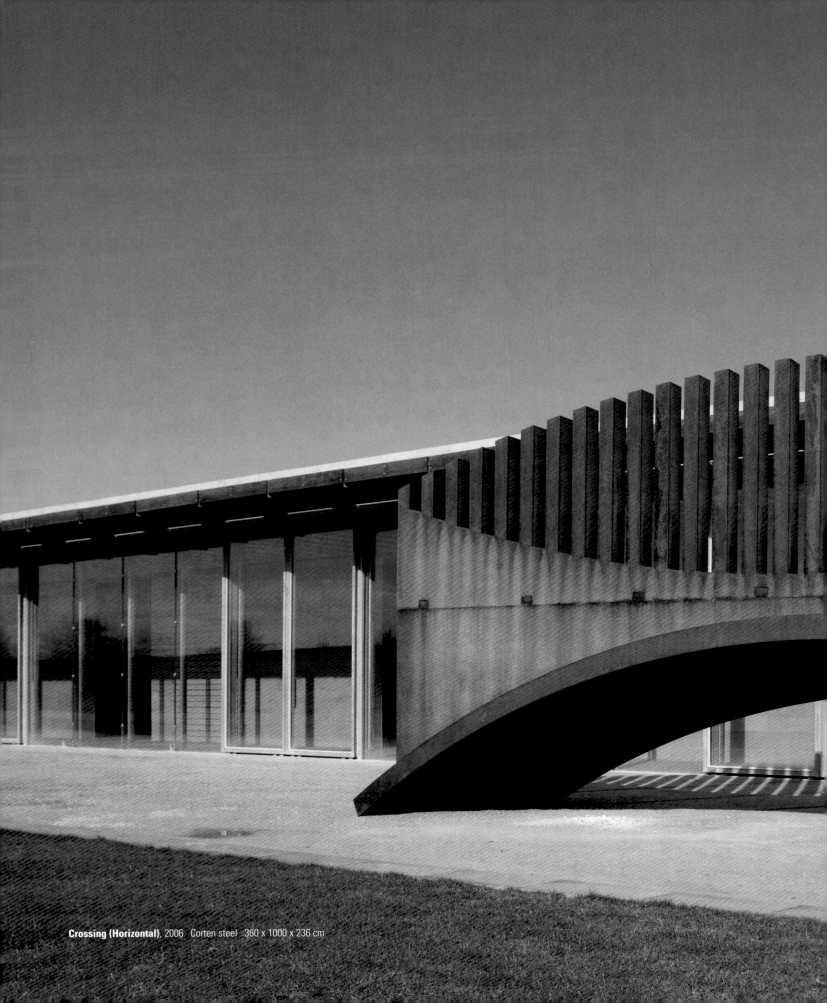

Crossing (Horizontal), 2006 Corten steel 360 x 1000 x 236 cm

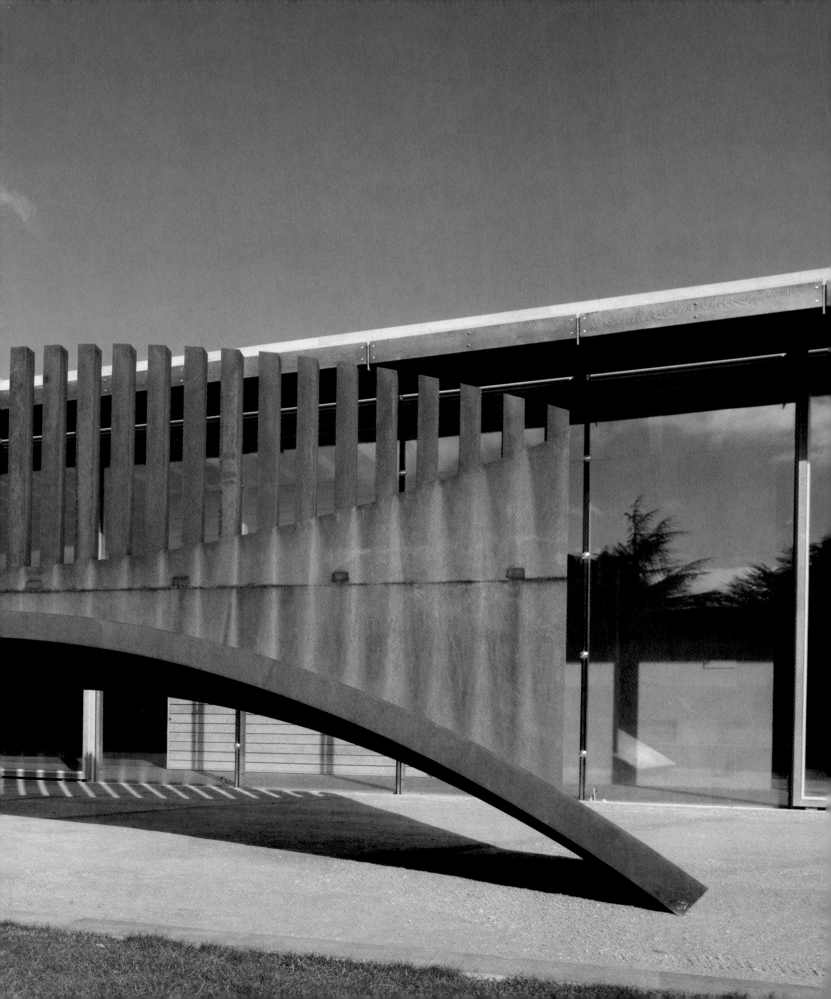

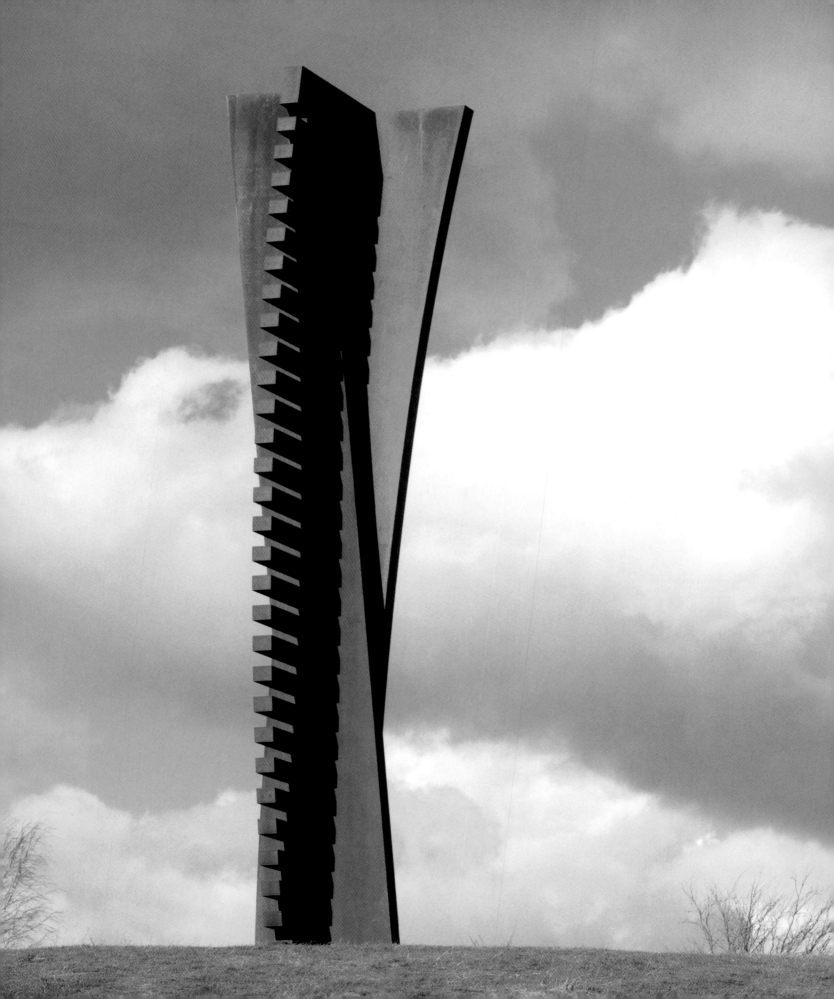

Crossing (Vertical), 2006 Corten steel 1000 x 258 x 232 cm

Wide Passage, 2007 Corten steel 92 x 605 x 94 cm

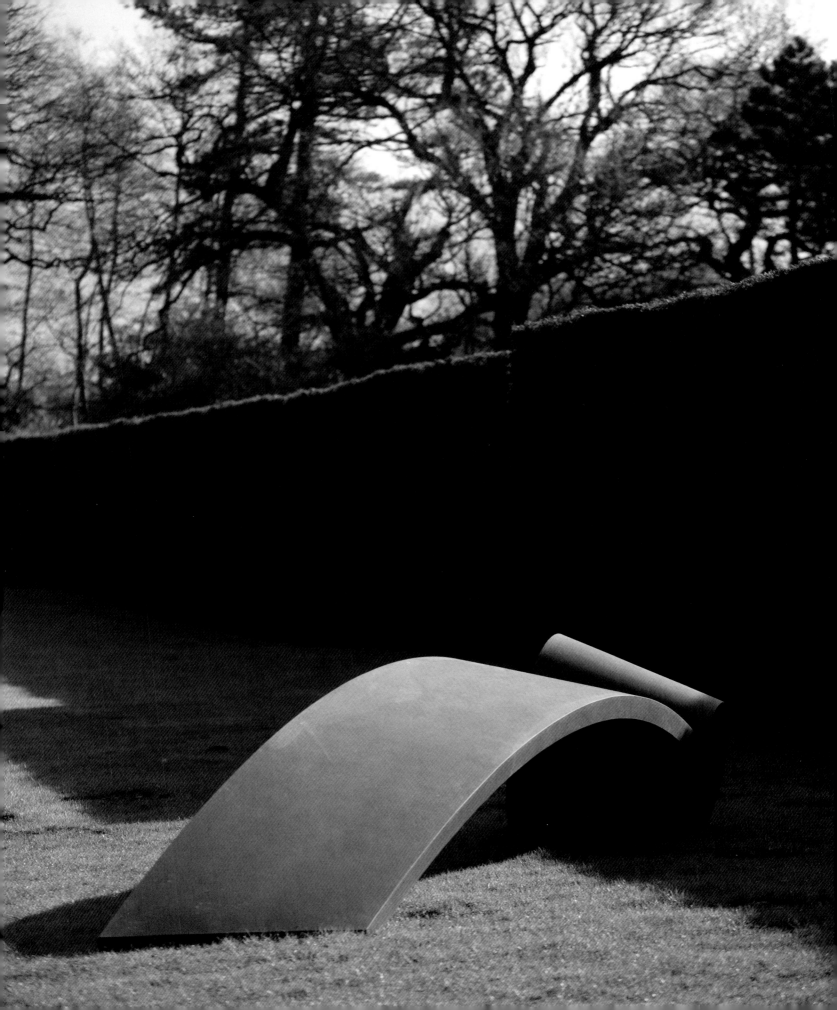

Venetian Twist IV, 2007 Polished wood 51 x 172.5 x 23 cm

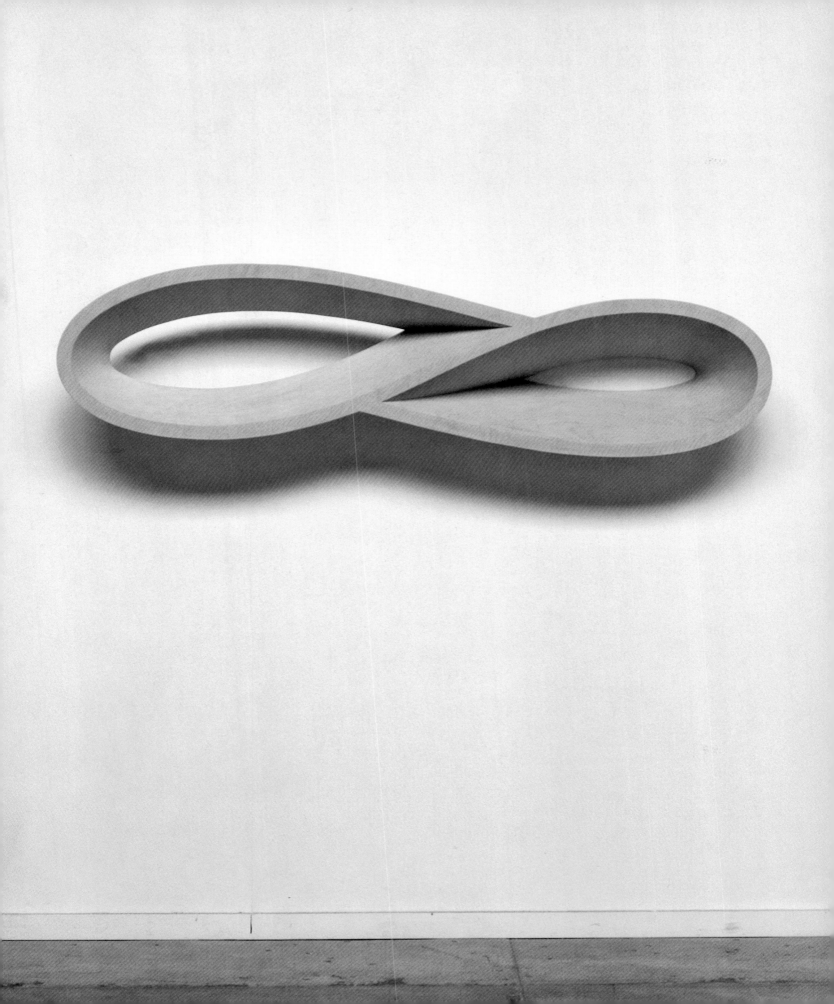

List of Works

Front endpaper
Working drawing for *Han River II*, 1988 (detail). Pencil on paper, 70 x 100 cm. Collection of the artist

Page 18
Three Silent Shapes II, 1965. Pencil and pastel on paper, 50.8 x 38 cm. Courtesy Galerie Scheffel, Bad Homburg, Germany

Page 20
Figure with Balloon, Matches and Shapes, 1965. Painted fibreglass and metal wire, 36 x 54 x 29.5 cm. Courtesy Galerie Scheffel, Bad Homburg, Germany

Page 21
All Space, 1966. Painted fibreglass, 183 x 112 x 109 cm. Courtesy Galerie Scheffel, Bad Homburg, Germany

Page 22
Bomb Factory, 1964. Pencil and pastel on paper, 22 x 57 cm. Collection of the artist

Page 23
Overcast, 1966. Painted fibreglass, 350 x 120 x 150 cm. Collection of the artist

Page 24
Northwest, 1967. Painted fibreglass, 245 x 350 x 25 cm. Whereabouts unknown

Page 27
Soda Lake, 1968, with dance choreographed by Richard Alston. Dancer: Mark Baldwin

Page 29
Drawing 439, 1984. Charcoal and pastel on paper, 152.2 x 75 cm. Private collection, Canada

Page 31
Working drawing for *Rydbo (small)*, 1989. Pencil on paper, 73 x 59.5 cm. Collection of the artist

Pages 32–3
Sketchbooks. Clockwise from top left: 1988, 2007, 2007, 2003. 11.5 x 35 cm. Collection of the artist

Page 34
Working drawing for *Chinese Whispers IV*, 2007. Pencil on paper, 84 x 59.5 cm. Collection of the artist

Page 35
Piz la Margna, Engadine, Switzerland, 28/12/07. Pencil and wash on paper, 15 x 42 cm. Collection of the artist

Page 36 top
Larch Twigs in Snow, 1989. Pencil and wash on paper, 17.5 x 24.5 cm. Collection of the artist

Page 36 bottom
Soglio with Helicopter, 29/12/01. Pencil and wash on paper, 15 x 41.5 cm. Private collection, Koenigstein, Germany

Pages 38–9
Cypriot Pots, 1992. Pencil and wash on paper, 15 x 41.5 cm. Collection of the artist

Page 40
Sketchbook. Drawing for *Soglio*. Collection of the artist

Page 41
Soglio (Schoenthal), 1994. Corten steel, 550 x 1100 x 308 cm. Sculpture at Schoenthal Monastery, Langenbruck, Switzerland

Page 43
Pocket II, 1972. Painted aluminium, 305 x 76 x 53 cm. First version of two: Leeds City Art Gallery; second version of two: Terry Inch, Los Angeles

Page 45
Plateau Marker, 1971. Painted fibreglass and aluminium, 102 x 412 x 7.6 cm. Tate, London

Page 46
Experiment with Pendula, 1965. Pencil and pastel on paper, 22.8 x 18 cm. Courtesy Galerie Scheffel, Bad Homburg, Germany

Page 47
House on Fire, 1964. Pencil and pastel on paper, 17.5 x 23 cm. Collection of the artist

Page 49
Lone Figure with Balloon, 1965. Painted fibreglass, wood and metal wire, 33.6 x 24 x 20 cm. Private collection, Stuttgart

Page 50
Three Shades, 1965. Pencil on paper, 18 x 22.7 cm. Collection of the artist

Page 51
Freeze I, 1965. Painted fibreglass, perspex and steel, 76 x 51 x 51 cm. Kettle's Yard Collection, University of Cambridge

Page 52
Look Out, 1966. Painted fibreglass, 129.5 x 190.5 x 30.5 cm. First version of two: Arts Council of England; second version of two: Collection of the artist

Page 53
Magnet, 1966. Painted fibreglass, 270.5 x 409 x 198 cm. Collection of the artist

Page 54
Wide Divide, 1967. Painted fibreglass, approximately 150 x 370 x 30 cm. Collection of the artist

Page 55
Great Ledge, 1967. Painted fibreglass and steel, 168 x 152 x 123 cm. Collection of the artist

Page 56
Humming Hill, 1967. Painted fibreglass and steel, 94 x 244 x 91.5 cm. Arts Council of England

Page 57
Tower, 1968. Painted fibreglass and aluminium, 280 x 97 x 42 cm. First version of two: Charles Cowles, New York; second version of two: collection of the artist

Page 58
Spike, 1970. Painted aluminium, 254 x 4 x 4 cm. Collection of the artist

Page 59
Soda Lake, 1968. Painted fibreglass and aluminium, 268 x 265.5 x 61 cm. First version of three: Tito del Amo, Los Angeles; second version of three: Arts Council of England; third version of three: collection of the artist

Pages 60–1
Crest, 1973. Painted aluminium, 44.5 x 393 x 68.5 cm. Devonshire Collection, Chatsworth, England

Page 62
Untitled, 1972. Charcoal on paper, 56 x 76 cm. Arts Council of England

Page 63
Untitled (Ragged), 1972. Charcoal on paper, 56 x 76 cm. Collection of the artist

Page 64 top
Two Ellipses, 1974. Charcoal on paper, 56 x 101 cm. Collection of the artist

Page 64 bottom
Two Bars, 1974. Charcoal on paper, 74 x 101 cm. Devonshire Collection, Chatsworth, England

Page 65 top
Untitled, 1973. Charcoal on paper, 55.8 x 76.4 cm. Collection of the artist

Page 65 bottom
Untitled, 1975. Charcoal on paper, 56 x 76 cm. Collection of Mr and Mrs J. G. Studholme, England

Page 66
Drawing 108, 1979. Charcoal on paper, 153 x 122 cm. Collection of the artist

Page 67
Six Bars, 1971. Painted plastic and aluminium, 335 x 884 x 8 cm. Collection of the artist

Pages 68–9
Precinct III, 1975. Painted aluminium, 115 x 395 x 82.5 cm.
British Council Collection

Pages 70–1
Black Minus, 1975. Painted aluminium, 258 x 410 x 125
cm. Kunsthaus Zurich

Page 72
Drawing A27, 1979. Charcoal on paper, 122 x 153 cm.
Collection of the artist

Page 73
Four, 1976. Painted aluminium, 252 x 222 x 84 cm.
Arts Council of England

Page 74
Drawing A12, 1977. Charcoal on paper, 129 x 153 cm.
Arts Council of England

Page 75
Drawing 85, 1979. Charcoal on paper, 76.3 x 101.5 cm.
Collection of the artist

Pages 76–7
Drawing A33, 1978. Charcoal on paper, 130 x 155 cm.
Sydney Museum of Contemporary Art

Page 78
Drawing 95, 1979. Charcoal on paper, 152 x 122 cm.
Private collection, Cologne

Page 79
Key (stone), 1979. Painted aluminium, 59 x 160 x 53.5
cm. Hammersmith Hospital Art Collection, England

Page 80
Intrusions/Exclusions, 1980. Painted aluminium,
127 x 107 x 19 cm. Collection Klaus Unger,
Schaffhausen, Switzerland

Page 81
Ammonite, 1980. Painted aluminium, 157 x 151 x 70 cm.
Private collection, Denmark

Page 82
Air Pocket, 1981. Painted aluminium, 135 x 146.5 x 56.5
cm. Annagret and Reinhart Freudenberg, Heidelberg

Page 83
Entrance to an Unnamed Place, 1981. Painted aluminium,
289.5 x 616 x 56 cm. Tokyo Metropolitan Art Museum

Page 85
Geography of an Unnamed Place, 1981. Painted
aluminium, 101 x 96 x 61 cm. British Council
Collection

Page 86
Drawing 199, 1981. Charcoal on paper, 137.2 x 101.7 cm.
Nationalgalerie, Berlin

Page 87
Drawing 222, 1981. Charcoal on paper, 137.2 x 101.7 cm.
Nationalgalerie, Berlin

Page 88
Drawing 253, 1982. Charcoal and pastel on paper,
75.6 x 137.3 cm. British Council Collection

Page 89
Black Shoal, 1982. Painted aluminium, 231 x 96 x 32.5
cm. Collection of the artist

Pages 90–1
Study for Australian National Gallery (First Version),
1982. Painted aluminium, 266.5 x 591.5 x 56 cm.
Collection of the artist

Page 92
Drawing 406, 1985. Charcoal and pastel on paper,
133 x 165 cm. British Airways Art Collection

Page 93
Cedar of Lebanon, 1984. Painted aluminium,
248 x 235 x 97.8 cm. Courtesy Annely Juda Fine Art,
London

Page 94
Drawing 586, 1987. Gouache and charcoal on paper,
152 x 120.5 cm. Clifford Chance Art Collection, London

Page 95
Gaze Large, 1988. Cast bronze (unique), 243 x 134 x 177
cm. Tate, London

Page 96
Drawing 739, 1989. Gouache and charcoal on paper,
153 x 102 cm. Collection of the artist

Page 97
Drawing 753, 1990. Gouache and charcoal on paper,
153 x 102 cm. Collection of the artist

Pages 98 and 99
Introspective Sentry, 1992. Corten steel, 450 x 366 x 153
cm. Private collection, Germany

Page 100
Narrow Fex Valley, 1990. Phosphor bronze,
74.5 x 86 x 72 cm. Professor Michele Baviera Collection,
Zurich

Page 101
Glacier, 1991. Phosphor bronze, 223 x 179 x 79 cm.
Unilever Collection, Rotterdam

Pages 102–3
Acorn, 1990. Corten steel, 173.5 x 291 x 247.5 cm.
Banque Lambert Collection, Brussels

Pages 104–5
Soglio (Schoenthal), 1994. Corten steel, 550 x 1100 x 308
cm. Sculpture at Schoenthal Monastery, Langenbruck,
Switzerland

Pages 106 and 107
Within and Without II, 1999. Corten steel,
244.6 x 250 x 135 cm. Hall Collection, Connecticut

Page 108
Finally Beginning, 1998. Polished wood, 165.5 x 184 x 36.5
cm. Courtesy Annely Juda Fine Art, London

Page 109
Drawing 1089, 1998. Gouache and charcoal on paper,
50 x 46.5 cm. Private collection, Bad Homburg, Germany

Page 111
Ship-to-Shore, 1998. Polished wood, 208 x 120 x 35 cm.
Global Crossing Collection, London

Page 112
Drawing 996, 1995. Gouache and charcoal on paper,
153 x 122 cm. Courtesy Annely Juda Fine Art, London

Page 113
Drawing 1053, 1997. Gouache and charcoal on paper,
122 x 153 cm. Collection of the artist

Page 114
Spy, 1998. Polished wood, 85 x 49.5 x 25 cm. Courtesy
Galerie Scheffel, Bad Homburg, Germany

Page 116
Arc, 1999. Corten steel, 500 x 241 x 229 cm.
Landesbank Rheinland-Pfalz, Mainz, Germany

Page 117 top and bottom
Big River, 1998. Corten steel, 540 x 804 x 408 cm.
The Daimler Art Collection, Stuttgart

Pages 118–19
The Now, 2000. Cast bronze (unique), 277 x 350 x 120
cm. Collection of the artist, courtesy of the Cass
Sculpture Foundation, Goodwood

Page 120
Book drawings. Clockwise from top left: *1273* (from
The Spire by William Golding), 2002; *1295* (from *The
Waste Land* by T. S. Eliot), 2004; *1280* (from *A Wave*
by John Ashbery), 2003; *1294* (from *After Nature* by
W. G. Sebald), 2004; *1259* (from *Underworld* by Don de
Lillo), 2002; *1291* (from *Heart of Darkness* by Joseph
Conrad), 2003. All carbon on paper, 23.5 x 24 cm.
Collection of the artist

Page 121
Drawing 1151 (from *The Modular* by Le Corbusier),
1999. Charcoal on paper, 126 x 122 cm. Collection of
the artist

Page 123
Snow Light, 2004. Polished wood, 160 x 160 x 29.6 cm.
Courtesy Galerie Lutz und Thalmann, Zurich

Page 124
The Hour of Dusk, 2000. Polished wood, 222 x 167.4 x 36
cm. Collection of the artist

Page 125
Hidden Valley, 1999. Polished wood, 146 x 238 x 78 cm.
Kunsthalle Mannheim, Germany

Page 126
Drawing 1270, 2002. Charcoal on paper, 152 x 122 cm.
Courtesy Annely Juda Fine Art, London

Page 127
Drawing 1256 (with Korean text), 2002. Charcoal and
collage on paper, 70 x 100 cm. Collection of the artist

Page 129
Winterreise, 2003. Polished wood, 122.5 x 122.5 x 22 cm.
Collection of the artist

Pages 130–1
Slow Motion, 2001. Painted steel, 500 x 424 x 303 cm.
Courtesy Galerie Scheffel, Bad Homburg, Germany

Page 133
Drifter Diptych, 2004. Polished wood, 331.5 x 182.3 x 31
cm. Courtesy Annely Juda Fine Art, London

Page 134
Drawing 1436, 2007. Gouache and charcoal on paper,
152 x 122 cm. Private collection, Bad Homburg,
Germany

Page 135
Drawing 1430, 2007. Gouache and charcoal on paper,
152 x 122 cm. Collection of the artist

Page 136
Drawing 1422, 2007. Gouache and charcoal on paper,
152 x 122 cm. Collection of the artist

Page 137
Drawing 1435, 2007. Gouache and charcoal on paper,
152 x 122 cm. Collection of the artist

Page 139
*Drawings 1402, 1403, 1412, 1413, 1415, 1404, 1411,
1405, 1416*, 2006. Gouache and charcoal on paper,
42 x 29.5 cm (each). Courtesy Galeria Pelaires, Palma
de Mallorca

Page 140
Drawing 1335, 2004. Gouache and charcoal on paper,
57.5 x 76.5 cm. Courtesy Annely Juda Fine Art, London

Page 141
Drawing 1333, 2004. Gouache and charcoal on paper,
57.5 x 76.5 cm. Courtesy Annely Juda Fine Art, London

Page 142
In the Bergell (Stampa), 2006. Polished wood, 95 x 300.6
x 41 cm. Courtesy Annely Juda Fine Art, London

Page 143
In the Bergell (Soglio), Large, 2006. Polished wood,
266 x 46.2 x 19 cm. Courtesy Annely Juda Fine Art,
London

Pages 144–5
Crossing (Horizontal), 2006. Corten steel, 360 x 1000
x 236 cm. Collection of the artist

Pages 146–7
Crossing (Vertical), 2006. Corten steel, 1000 x 258 x 232
cm. Collection of the artist

Page 149
Wide Passage, 2007. Corten steel, 92 x 605 x 94 cm.
Courtesy Galerie Scheffel, Bad Homburg, Germany

Page 151
Venetian Twist IV, 2007. Polished wood, 51 x 172.5 x 23
cm. Courtesy Annely Juda Fine Art, London

Biography

1943
Born in Bristol

1960–64
Studied at West of England College of Art, Bristol

1964–67
Studied at Royal College of Art, London

1967–69
Harkness Fellowship, USA

1971–74
Tutor, Royal College of Art, London

1974–81
Principal Lecturer, Head of MA Sculpture, Chelsea
School of Art, London

1977–79
External examiner, Royal College of Art, London

1979–83
Faculty member of British School, Rome

1992–94
External examiner, Royal College of Art, London

2001
Residency at Chretzeturm, Stein am Rhein, Switzerland

2003
Elected to Royal Academy of Arts

Lives and works in London

Exhibitions

Solo Exhibitions

1967
Galerie Givaudan, Paris

1968
Nicholas Wilder Gallery, Los Angeles

1970
Galerie Neuendorf, Hamburg
Galerie Neuendorf, Cologne
Serpentine Gallery, London

1971
Studio Show, London

1972
Nicholas Wilder Gallery, Los Angeles
Felicity Samuel Gallery, London

1974
Felicity Samuel Gallery, London
Galleria Primo Piano, Rome
Robert Elkon Gallery, New York

1975
Galleri Galax, Gothenberg
Galerie Jacomo-Santiveri, Paris

1976
Felicity Samuel Gallery, London
Arnolfini Gallery, Bristol

1977
Robert Elkon Gallery, New York
Tranegaarden Kunstbibliotek, Copenhagen

1978
University of Melbourne Art Gallery
Annely Juda Fine Art, London
Institute of Modern Art, Brisbane
Round House Gallery, London (installation)
Chandler Coventry Gallery, Sydney
Aberdeen Art Gallery
Geelong Gallery, Geelong, Australia
Shepparton Art Gallery, Shepparton, Australia
Newcastle Region Art Gallery, Newcastle, Australia

1979
Galleria Primo Piano, Rome
Robert Elkon Gallery, New York
Benalla Art Gallery, Benalla, Australia
Undercroft Gallery, University of Western Australia,
 Perth
Southampton University Art Gallery (installation)
Galerie Reckermann, Cologne
Peterloo Gallery, Manchester

1980
Ceolfrith Gallery, Sunderland Arts Centre
St Paul's Gallery, Leeds
City Museum and Art Gallery, Stoke-on-Trent
Warwick Gallery, London
Nishimura Gallery, Tokyo
South Hill Park Arts Centre, Bracknell

1981
Galerie Maeght, Paris
Juda Rowan Gallery, London

1982
Staatliche Kunsthalle Baden-Baden
Galerie Maeght, Zurich
Galerij S65, Aalst, Belgium
Gallery Kasahara, Osaka

1983
Robert Elkon Gallery, New York
Galerie Maeght Lelong, Paris
Yuill/Crowley Gallery, Sydney

1984
Galerie Reckermann, Cologne
Nishimura Gallery, Tokyo
Galerie Klaus Lüpke, Frankfurt am Main

1985
Juda Rowan Gallery, London
Galerij S65, Aalst, Belgium
Galerie Nicole Gonet, Lausanne

1986
Galerie Renée Ziegler, Zurich

1987
Fondation Veranneman, Kruishoutem, Belgium
Garry Anderson Gallery, Sydney
Annely Juda Fine Art, London
Galerie Hete Hünermann, Düsseldorf

1988
Nishimura Gallery, Tokyo
Galerie Renée Ziegler, Zurich

1989
Galerie Blanche, Stockholm
Studio 5 Gallery, Chippenham
Galerie Hans Mayer, Düsseldorf

1990
Garry Anderson Gallery, Sydney
Deutscher Gallery, Melbourne

1991
Annely Juda Fine Art, London
Galerie Terbrüggen, Heidelberg

1994
Galerie Nova, Pontresina, Switzerland

1995
Galerie Renée Ziegler, Zurich
Fondation Veranneman, Kruishoutem, Belgium

1996
Annely Juda Fine Art, London
Shell Technology and Research Centre, Amsterdam

1997
Fondation Veranneman, Kruishoutem, Belgium
Economist Plaza, London
Park Ryu Sook Gallery, Seoul

1998
New York Studio School Gallery

1999
Galerie Hans Mayer, Düsseldorf

2000
Konstruktiv Tendens, Stockholm
Annely Juda Fine Art, London
Galleri C. Hjärne, Helsingborg, Sweden
Park Ryu Sook Gallery, Seoul

2001
Schoenthal Monastery, Langenbruck, Switzerland

2002
Art Space Gallery, London

2003
Annely Juda Fine Art, London

2004
Galleri C. Hjärne, Helsingborg, Sweden
Kunsthalle Mannheim, Germany
Galerie Scheffel, Bad Homburg, Germany

2005
Annely Juda Fine Art, London
Galería Pelaires, Palma de Mallorca
Park Ryu Sook Gallery, Seoul

2006
Galerie Lutz und Thalmann, Zurich

2007
Centre Cultural Contemporani Pelaires, Palma de
 Mallorca
Galerie Scheffel, Bad Homburg, Germany
Kulturzentrum Englische Kirche, Bad Homburg, Germany

2008
Yorkshire Sculpture Park, Wakefield
Park Ryu Sook Gallery, Seoul

Selected Group Exhibitions

1967
'Salon de Mai', Musée National d'Art Moderne, Paris;
 Maison de la Culture, Amiens

1967–69
'New British Painting and Sculpture', UCLA Galleries,
 Los Angeles; University Art Museum, Berkeley;
 Portland Art Museum; Vancouver Art Gallery;
 Museum of Contemporary Art, Chicago;
 Contemporary Arts Museum, Houston

1972
'Eight Individuals', Arts Council touring exhibition,
 Derby Museum and Art Gallery; Southampton;
 Folkestone; Billingham; Sheffield
'Untitled 3', Penthouse, Museum of Modern Art,
 New York
'Drawing', Museum of Modern Art, Oxford

1973
'Young English Artists', Göteborgs Konstmuseum,
 Gothenberg

1975
9th Paris Biennale
'The Condition of Sculpture', Hayward Gallery, London

1976
'Arte Inglese Oggi (1960–76)', Palazzo Reale, Milan

1977
'Plan and Space', Academy of Fine Arts, Ghent
'Documenta VI', Kassel

1978
McCrory Collection, Tel Aviv Museum of Art

1979
'The British Art Show', Mappin Art Gallery, Sheffield

1979–81
'Constructivism and the Geometric Tradition', McCrory
 Corporation Collection, Albright-Knox Art Gallery,
 Buffalo; Dallas Museum of Fine Arts; San Francisco
 Museum of Modern Art; Museum of Contemporary
 Art, La Jolla; Seattle Art Museum; Carnegie Museum
 of Art, Pittsburgh; William Rockhill Nelson Gallery of
 Art and Atkins Museum of Fine Arts, Kansas City;
 The Detroit Institute of Arts; Milwaukee Art Center

1980
'Reliefs: Formprobleme zwischen Malerei und Skulptur
 im 20. Jahrhundert', Westfälisches Landesmuseum,
 Münster; Kunsthaus Zurich

1981
'Nature du Dessin', Centre Georges Pompidou, Paris
'Five Sculptors (Biederman, Gummer, Hall, Kendrick,
 Oz)', The Clocktower, New York

1981–82
'British Sculpture in the Twentieth Century Part II:
 Symbol and Imagination 1951–80', Whitechapel
 Art Gallery, London

1982
'Aspects of British Art Today', Tokyo Metropolitan Art
 Museum; Tochigi Prefectural Museum of Fine Arts,
 Utsunomiya; National Museum of Art, Osaka;
 Fukuoka Art Museum; Hokkaido Museum of Modern
 Art, Sapporo
Carnegie International, Carnegie Museum of Art,
 Pittsburgh

1983
'Drawing in Air', Sunderland Arts Centre; Glynn Vivian
 Art Gallery and Museum, Swansea; Leeds City Art
 Gallery; Henry Moore Institute, Leeds

1984
'British Contemporary Drawings', Museum of Modern
 Art, Shiga, Otsu City

1984–85
'Sculptors' Drawings', British Council touring exhibition,
 Hyogo Prefectural Museum of Art; tour of Japan,
 Korea and the Far East

1986
'A Focus on British Art', International Cultural Centre,
 Antwerp

1988
'Die Ecke', Musée Cantonal des Beaux-Arts, Sion,
 Switzerland
Olympiad of Art, Seoul

1988–89
'Britannica: Trente Ans de Sculpture', Musée des
 Beaux-Arts André Malraux, Le Havre; Museum van
Hedendaagse Kunst, Antwerp; Centre Régional d'Art
 Contemporain Midi-Pyrénées, Labège-Innopole,
 Toulouse

1991
XV Biennale Internazionale del Bronzetto e della
 Piccola Scultura, Palazzo della Ragione, Padua

1993
'Drawings in Black and White', Museum of Modern
 Art, New York

1994
'Prints of Darkness', Fogg Art Museum, Harvard
 University, Cambridge
'British Drawings: A Selection from the Collection',
 Museum of Modern Art, New York

1995
'A Passion for the New, New Art in Tel Aviv Collections',
Helena Rubinstein Pavilion for Contemporary Art,
Tel Aviv

1997
'A Changed World', British Council touring exhibition,
Hindu Gymkhana, Karachi; The Old Fort, Lahore

1999
'Zum Kreis', Museum Zu Allerheiligen, Schaffhausen,
Switzerland
''45–'99 – A Personal View of British Painting and
Sculpture by Bryan Robertson', Kettle's Yard,
Cambridge; Leicester City Museum

2000
'Beyond the Circle', Moran Museum, Seoul

2001
'Blickachsen 3', Bad Homburg, Germany
'Out of Line: Drawings from the Arts Council Collection',
York City Art Gallery; tour

2002
'Sculpture at Salisbury Cathedral'

2003
'Blickachsen 4', Bad Homburg, Germany
'Donation Jeunet', Musée d'Art et d'Histoire, Neuchâtel,
Switzerland

2006
'Drawing Inspiration', Abbot Hall Art Gallery, Kendall
'2006 Beaufort, Inside', PMMK Museum of Modern
Art, Ostend, Belgium
'2006 Beaufort, Outside', Blankenberge, Belgium

2007
'Relationships: Contemporary Sculpture', York Art
Gallery
'1907–2007': Hundert Jahre', Kunsthalle Mannheim,
Germany

2008
Seoul Olympics 20th anniversary exhibition, Seoul
Olympic Museum of Art

Site-Specific Projects

1982
Wall-mounted sculpture for entrance to Australian
National Gallery, Canberra. Painted aluminium,
365 x 730 cm

1983
Wall-mounted sculpture for foyer of London IBM
headquarters. Painted aluminium, 213 x 244 cm

1984
Wall-mounted sculpture for Airbus Industrie, Toulouse.
Painted aluminium, 167 x 244 cm

1985
Wall-mounted sculpture for Museum of Contemporary
Art, Hiroshima. Painted aluminium, 268 x 247 x 46 cm

1987
Free-standing sculpture for foyer of London and
Continental Bank, London. Bronze, 183 x 107 x 107 cm

1988
Free-standing sculpture for Olympic Park, Seoul.
Cast bronze, 472 x 457 x 365 cm

1989
Two-part wall relief for Providence Towers, Dallas.
Painted and gilded wood, 411 x 1460 cm

1990
Brick wall in centre of Kingston-upon-Thames.
Approximately 90m

1992
Free-standing sculpture commissioned by British
Petroleum, sited at Warwick University. Bronze,
457 x 305 x 274 cm
Free-standing sculpture for stairwell of Clifford Chance
offices. Brass, 198 x 91 x 91 cm

1993
Free-standing sculpture for entrance to Thameslink
Road Tunnel, London Docklands. Steel,
914 x 838 x 305 cm

1994
Wall sculpture for Glaxo Wellcome Medicines
Research Centre, Stevenage. Polished wood, in two
parts: 210 x 350 x 40 cm and 250 x 250 x 60 cm

1996
Wall sculpture for Nippon Telegraph and Telephone,
Tokyo. Polished wood, 200 x 300 x 60 cm

1998
Free-standing sculpture outside entrance to Nippon
Telegraph and Telephone, DoCoMo, Kanagawa
Prefecture, Japan. Painted steel, 333 x 474 x 255 cm

2001
Free-standing sculpture set in landscape at Schoenthal
Monastery, Langenbruck, Switzerland. Corten steel,
360 x 828 x 192 cm

2002
Free-standing sculpture for private collection in
Germany. Painted steel, 500 x 136 x 126 cm

2003
Wall-mounted sculpture for Rexfield Golf Club, Seoul.
Varnished wood, 371 x 329 x 147 cm
Free-standing sculpture for Bank of America, Canary
Wharf, London. Corten steel, 230 x 230 x 125 cm

2005
Wall-mounted sculpture for Said Business School,
University of Oxford. Polished wood, 320 x 212 x 49 cm

2006
Free-standing sculpture for Sparkasse, Loerrach,
Germany. Corten steel, 320 x 163 x 113 cm
Wall-mounted sculpture for Bank of International
Settlements, Basel. Polished wood, 130 x 280 x 38 cm

2008
Free-standing sculpture in corten steel for Energiedienst
AG, Laufenburg, Switzerland. 293 x 300 x 161 cm

Collections

Public Collections

Aberdeen Art Gallery
Arnolfini Trust, Bristol
Art Gallery of New South Wales, Sydney
Art Institute of Chicago
Arts Council of Great Britain
Australian National Gallery, Canberra
Bradford City Museum
Bristol City Museums and Art Gallery
British Ambassador's residence, Washington DC
British Art Medal Society, London
British Council
British Museum, London
Chelsea and Westminster Hospital, London
Contemporary Arts Society, London
Council for National Academic Awards, London
Dallas Museum of Fine Art
Department of the Environment, London
Fitzwilliam Museum, Cambridge
Fondation Veranneman, Kruishoutem, Belgium
Göteborgs Konstmuseum, Gothenberg
Government Art Collection, London
Herbert Art Gallery, Coventry
Huddersfield Art Gallery, Huddersfield
Iwaki City Museum of Modern Art, Japan
Kettering Art Gallery
Kettle's Yard, University of Cambridge
Kuntshalle Mannheim, Germany
Kunsthaus Zurich
Leeds City Art Gallery (McAlpine loan)
Leicestershire Local Education Authority
Los Angeles County Museum of Art
Louisiana Museum, Denmark
Middlesbrough City Art Gallery
Mildura Arts Centre, Australia
Musée d'Art et d'Histoire, Neuchâtel, Switzerland
Musée d'Art Moderne, Brussels
Musée National d'Art Moderne, Paris
Museum Im Kulturspeicher, Wurzburg, Germany
Museum of Contemporary Art, Hiroshima
Museum of Contemporary Art, Sydney
Museum of Modern Art, New York
Museum of Modern Art, Saitama
Museum of Modern Art, Toyama
National Museum of Art, Osaka
National Museum of Contemporary Art, Seoul
Neue Nationalgalerie, Berlin
Olympic Park, Seoul
Power Collection, Sydney
Said Business School, University of Oxford
Sapporo Art Park
Scottish Arts Council
Scottish National Gallery of Modern Art, Edinburgh
Sculpture at Schoenthal Monastery, Langenbruck,
 Switzerland
Sheffield Art Gallery
Southampton University Art Gallery

Tate, London
Tel Aviv Museum of Art
Tokyo Metropolitan Art Museum
University of Essex, Colchester
University of Melbourne Art Gallery
Victoria and Albert Museum, London
Victoria State Gallery, Melbourne
Wakefield Art Gallery
Warwick Arts Trust, London
Weishaupt-Forum, Ulm, Germany
Wolverhampton Polytechnic
York City Art Gallery

Selected Corporate Collections

Advokataktiebolaget Urban Jansson and Partners,
 Landskrona, Sweden
Airbus Industrie, Toulouse
Arthur Anderson & Co, London
AXA AG, Cologne
Bank for International Settlements, Basel
Bank of America, London
Bank of America, Paris
Banque Lambert, Brussels
British Airways
British Oxygen Company Ltd
British Petroleum
Business Design Centre, London
Chemical Bank, New York
Clifford Chance, London
Colonia Versicherung, Cologne
Daimler Art Collection, Stuttgart
Deutsche Bank, Athens
Deutsche Bank, London
Deutsche Industriebank AG, Düsseldorf
Energiedienst AG, Laufenburg, Switzerland
Fidelity, London
Gelco Corporation, Minneapolis
GlaxoSmithKline Research & Development, Stevenage
Global Crossing, London
Goldman Sachs, London
Helaba, Landesbank Hessen-Thüringen, London
IBM, London
Industriekreditbank, Düsseldorf
Landesbank Rheinland-Pfalz, Mainz
Landeszentralbank in Rheinland-Pfalz, Mainz
London and Continental Bank, London
London Docklands Limehouse Link
McCrory Corporation, New York
National Westminster Bank, New York
NTT, DoCoMo, Kanagawa Prefecture
NTT, Tokyo
Owens-Corning Fiberglas, New York
Providence Towers, Dallas
Prudential Corporation, London
Qantas Airlines
Rautaruukki Oy, Oulu, Finland
Rexfield, Seoul
Security Pacific Bank, London
Skandinaviska Enskilda Banken, Sweden
Stanhope Properties plc, London
Sun Alliance, London
Trinkaus und Burkhardt, Düsseldorf
Unilever Collection, London
Unilever Collection, Rotterdam
US Trust Company, New York

Selected Bibliography

1967
Mario Amaya, *Art and Artists*, May
R. C. Kennedy, *Art International*, May

1968
Fidel Danielli, *Art Forum*, November

1970
William Packer, *Art and Artists*, August

1972
Marina Vaizey, *Financial Times*, June
William Packer, *Art and Artists*, July

1974
Bernard Denvir, *Art International*, February
Marina Vaizey, *Financial Times*, 26 February

1975
Patricia Kaplan, *Art News*, January
Carter Ratcliff, *Art Spectrum*, January
Georgina Oliver, *Plus Minus Zero*, September

1976
R. C. Kennedy, *Art International*, March
John McEwen, *The Spectator*, 27 March
William Packer, *Financial Times*, 5 April

1977
Terence Maloon and Peter Rippon, *Artscribe*, November

1978
Nigel Hall: Sculpture and Drawings, exh. cat., Annely
 Juda Fine Art, London
John McEwen, *Art Forum*, April
Bryan Robertson, *Harpers & Queen*, May
John McEwen, *The Spectator*, 20 May
Nancy Borlase, *Melbourne Herald*, 15 July

1979
John Russell, *New York Times*, 20 April

1980
*Nigel Hall: Early Work with Sculpture and Drawings
 1965–1980*, exh. cat., Warwick Gallery, London
William Feaver, *Art News*, January
John Spurling, *New Statesman*, 30 May

1981
Nigel Hall, exh. cat., Galerie Maeght, Paris
Nigel Hall: Sculpture and Drawings, exh. cat., Juda
 Rowan Gallery, London
Sarah Kent, *Time Out*, 26 November – 3 December
Caroline Collier, *Arts Review*, 4 December
John McEwen, *The Spectator*, 19 December

1982
Nigel Hall: Skulpturen und Zeichnungen, exh. cat.,
 Staatliche Kunsthalle Baden-Baden

1983
Susanna Short, *The Sydney Morning Herald*, 27 October

1984
Carter Ratcliff, *Art in America*, January

1985
Nigel Hall: Recent Sculpture and Drawings, exh. cat.,
 Juda Rowan Gallery, London
Margaret Garlake, *Art Monthly*, April
John Russell Taylor, *The Times*, 9 April
Bryan Robertson, *Art & Australia*, Autumn

1987
Nigel Hall: Recent Sculpture and Drawings, exh. cat.,
 Annely Juda Fine Art, London
Elwyn Lynn, *The Weekend Australian*, 10 October

1991
Nigel Hall: Recent Sculpture and Drawings, exh. cat.,
 Annely Juda Fine Art, London
Phillip Ward-Green, *Arts Review*, 14 June
Heide Seele, *Feuilleton/Rhein-Neckar-Main*, 1 July

1994
Susan Loppert, *Contemporary Art*, Winter 1994–95

1996
Nigel Hall: Recent Sculpture and Drawings, exh. cat.,
 Annely Juda Fine Art, London
William Packer, *Financial Times*, 2 April
Charles Hall, *The Independent*, 23 April
John McEwen, *The Sunday Telegraph*, 28 April

1997
Andrew Lambirth, *The Independent*, 19 September

2000
Nigel Hall: Sculpture and Drawings, exh. cat., Annely
 Juda Fine Art, London

2002
Andrew Lambirth, *The Spectator*, 21 September

2003
Sue Hubbard, *The Independent*, 18 November

2004
Nigel Hall: Hidden Valleys, exh. cat., Kunsthalle
 Mannheim, Germany

2005
*Nigel Hall: Forms in Light and Shade, Recent Sculpture
 and Drawing*, exh. cat., Annely Juda Fine Art,
 London
Andrew Lambirth, *The Spectator*, 7 May

2007
Nigel Hall: Other Voices, Other Rooms, exh. cat., Galerie
 Scheffel, Bad Homburg, Germany
Martina Dreisbach, *Taunus Zeitung*, 8 September

Photographic Credits

This book was first published to coincide with the exhibition 'Nigel Hall: Sculpture and Drawing, 1965–2008' at the Yorkshire Sculpture Park, West Bretton, Wakefield from 15 March to 8 June 2008.

The text is drawn from transcriptions of interviews with the artist recorded by Andrew Lambirth for the *Artists' Lives* project for the National Life Stories. © The British Library

A note about the text. Since 1990 National Life Stories, the oral history fieldwork charitable trust based in the British Library Sound Archive, has been recording, in association with Tate Archive, the life stories of British artists for the *Artists' Lives* collection. Recordings can be accessed at the British Library, London, and at www.bl.uk/collections/sound-archive/history.html Academic users can also access selected interviews from this collection at http://sounds.bl.uk

Front endpaper: working drawing for *Han River II*, 1988 (detail). Pencil on paper, 70 x 100 cm
pp. 2–3: Nigel Hall's studio interior, 2008
Frontispiece: Nigel Hall in his studio, 2008
pp. 6–7, 8–9, 10–11, 12–13, 14–15, 16–17: installations from 'Nigel Hall: Sculpture and Drawing, 1965–2008' at the Yorkshire Sculpture Park, 2008
Back endpaper: wall of Nigel Hall's studio, 2008 (detail)

Design: Herman Lelie and Stefania Bonelli

Copy-editing and proofreading: Rosalind Neely
Colour origination: Altaimage Ltd
Printed in Belgium by Die Keure

Royal Academy Publications
Lucy Bennett, David Breuer, Sophie Oliver, Peter Sawbridge, Sheila Smith, Nick Tite

British Library Cataloguing-in-Publication Data
A catalogue record for this book is available from the British Library
ISBN 978-1-905711-30-7 (hardback)

Distributed outside the United States and Canada by Thames & Hudson Ltd, London
Distributed in the United States and Canada by Harry N. Abrams, Inc., New York